KENT
THROUGH TIME
Robert Turcan

BRADWELL
BOOKS

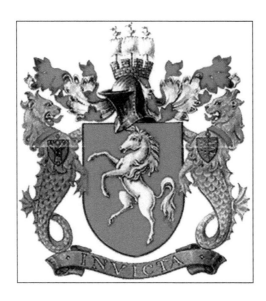

KENT'S MOTTO:
Invicta – Unconquered

To Christabel a much loved grandmother and all the maids of Kent

First published in 2012 by
Amberley Publishing for Bradwell Books

Amberley Publishing
The Hill, Stroud
Gloucestershire, GL5 4EP
www.amberley-books.com

Copyright © Robert Turcan, 2012

The right of Robert Turcan to be identified as the
Author of this work has been asserted in accordance
with the Copyrights, Designs and Patents Act 1988.

ISBN 978 1 4456 0730 6

British Library Cataloguing in Publication Data.
A catalogue record for this book is available from
the British Library.

Typeset in 9.5pt on 12pt Celeste.
Typesetting by Amberley Publishing.
Printed in the UK.

Introduction

Kent is the English county with the greatest variety of beautiful countryside. Punctuating its fields and woodlands are an amazing array of pretty towns and villages. That is to say nothing of its citizens, indigenous and visitors alike, who have contributed to the fame and fortune of this corner of land nearest the Continent. As a native this enthusiasm is inbred, but not blinkered by any lack of foreign travel or prejudice. The closer one studies the qualities and hidden treasures of this county the stronger your affection will become. Inevitably, however, personal choices had to be made to provide a pictorial selection of old and new images giving a reasonably comprehensive overall authentic view.

To illustrate Kent's farming prowess there are scenes from hop gardens and orchards which prove the validity of Kent's well known moniker as 'the garden of England'. A superb temperate climate, rich fertile soils and skilled workforce close to large urban markets have been the main economic drivers.

With most of the county bounded by sea the coastal towns are briefly mentioned one by one from north-eastwards to the North Foreland and then south past Dover to gradually follow the shore westwards to New Romney. Five of these historic towns comprise the Cinque Ports. They received this title in early medieval times, with freer rights of self government in return for defence obligations at times of threatened war. Continental invaders have been a perpetual danger so there are many surviving fortifications from the massive, impregnable Dover Castle to the clover leaf pattern Tudor forts, the Martell Towers of Napoleonic times and the humble yet nonetheless tough little pill boxes of the Second World War. Peacetime mariners have crewed paddle steamers, modern ferries and fishing boats. Two particularly renowned local fruits of the sea are Dover soles and Whitstable oysters.

A journey west to east across the interior or Weald passes through the major towns of Sevenoaks, Tunbridge Wells, Tonbridge, Maidstone, Ashford and Canterbury. Each has a unique character shaped by their geography and economic history. Tunbridge Wells retains its affluent regency smartness. To the north Rochester displays its historic identity as a city and a defensive strongpoint on the Medway. Proudly Maidstone is the centre of local government. Ashford is a vibrant expanding community with railway links that are still vital. Canterbury is perhaps the most visited because of the magnificence of its Cathedral.

Lastly a good selection of stately homes, castles and other large country house are featured as they so densely populate this lush countryside of outstanding natural beauty. Knowle, Penshurst, Scotney, Hever, Leeds and Saltwood are all included. However, due to the constraints of space some worthy examples have regrettably been omitted.

Hopefully readers will be inspired to seek out these further gems. Meanwhile the pictures here aim to show how Kent is not only improving through time but will continue to surprise and delight in the future.

Rough winds do shake the darling buds of May
And summer's lease hath all too short a date:

Shakespeare, Sonnet 18

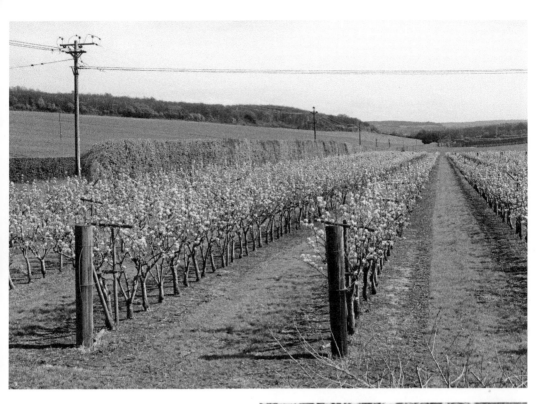

Fruit Growing

Kent is the cradle of the UK's fruit growing industry. Henry VIII's fruitier Richard Harries established a 100-acre plantation of cherries at Teynham. Today this part of the county known as the North Kent Horticultural Belt has many orchards laid out with intensive high performance planting schemes like the pear plantation in bloom above. Earlier orchards had less dense tree planting but higher roots stocks which required long ladders for pickers to reach their highest branches.

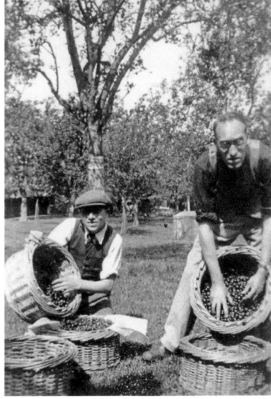

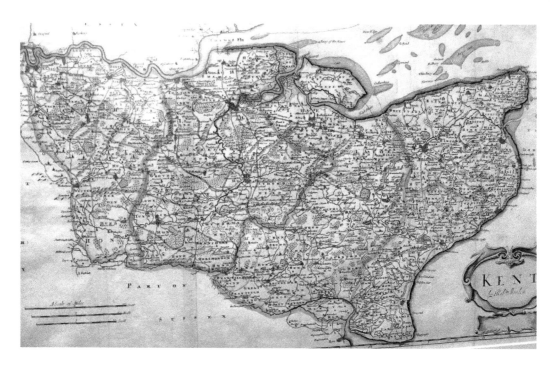

Antique Maps of Kent

Many illustrious cartographers including Saxton and Speed have produced maps of Kent. Two favourites from this author's collection are Morden's from 1695, which is the first to show the road system in any detail, and an 1806 one by John Carey, who pioneered modern map making so that it resembles the present ordinance survey.

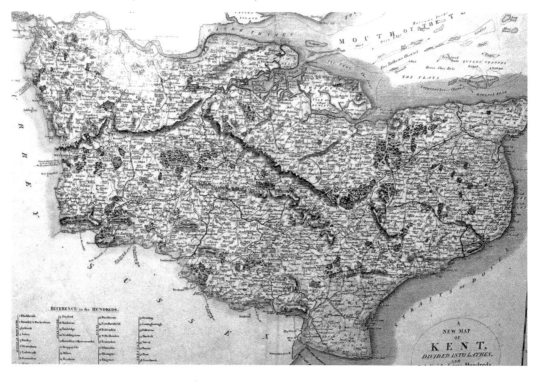

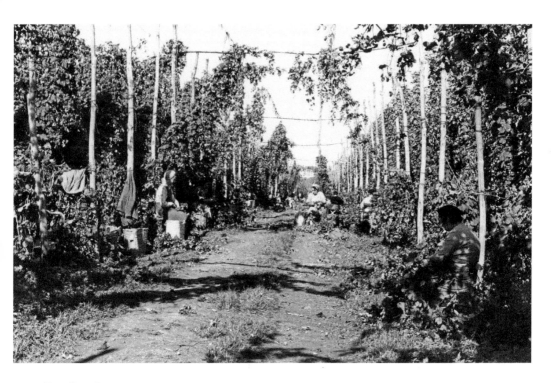

Hop Growing

Hop growing and oast houses have become synonymous with Kent. However, before introduction to the county in 1524 they were described as a pernicious weed in an earlier parliamentary petition. Extremely labour intensive to grow and harvest, many local and London workers were enlisted to assist at peak times.

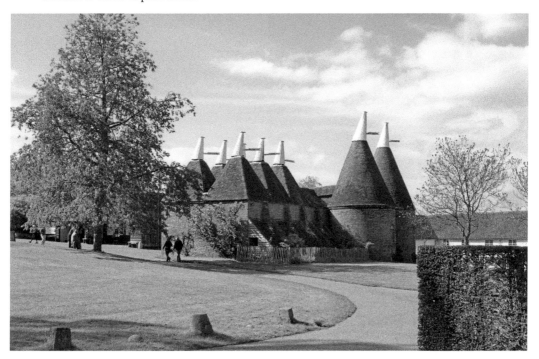

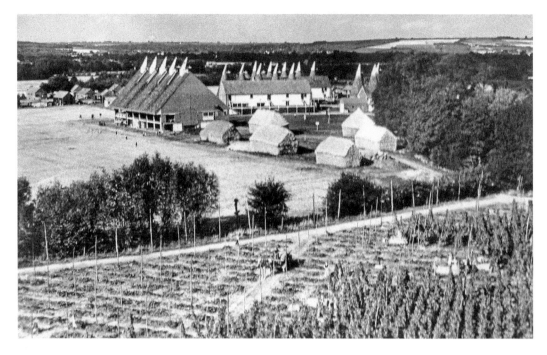

Hop Gardens

The above overview of an old style hop garden shows the bines with the flowers attached cut from their supports so that pickers can hand pick the vital petals containing the bitter flavour ingredient for beer. Below, the plants are just emerging from the ground in April to grow vigorously during the summer over a trellis of poles and strings.

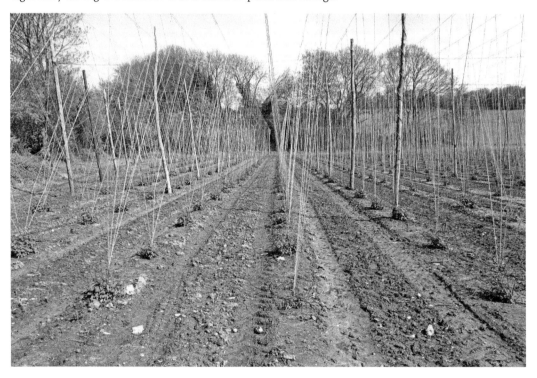

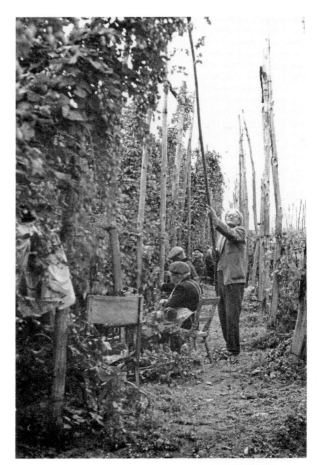

Hop Picking

These old photographs illustrate the communal effort that was required at hop picking time in September. Special trains from London transported workers and their families to farms which often provided accommodation huts for the season. Generations pulled together to boost their tally and increase income.

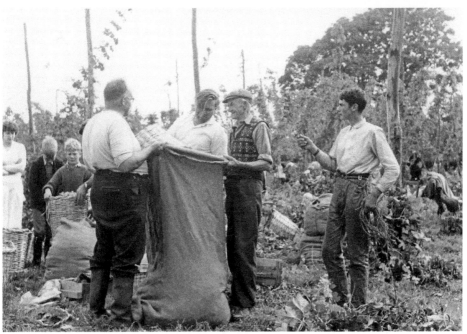

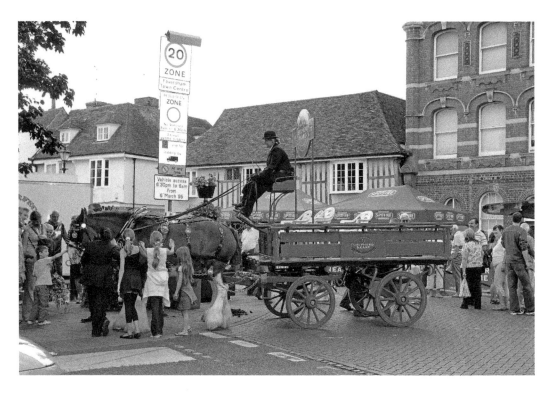

Hop Processing

After leaving the fields in large sacks called pockets, hops were skilfully dried on the farm in oast houses before being sold and transported to breweries. Shepherd Neame in Faversham is the oldest brewer in the UK and is proud to utilise locally grown hops in its prize-winning beverages. Part of this company's success is founded on traditional methods and support for community events such as the Faversham Hop Festival above.

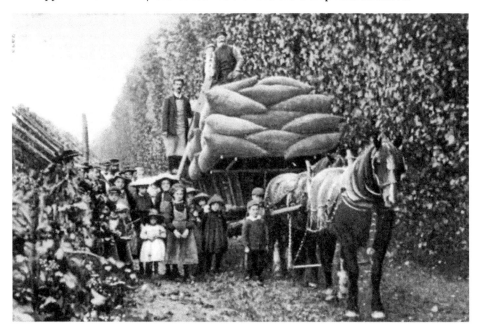

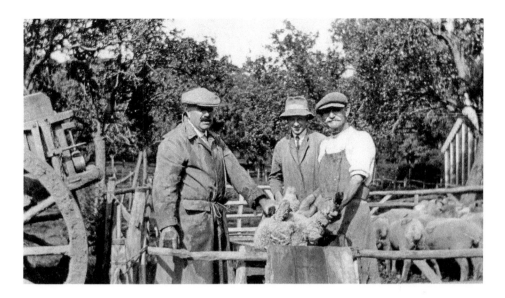

Sheep Farming

Sheep farming has been a major part of Kent's agricultural industry for many centuries. During Tudor times Faversham was the major English port for the export of wool. Owling or the export of wool without paying taxes was a prevalent illegal activity, together with smuggling along the many quiet creeks and inlets of Kent's long coastline close to the Continent. The Romney Marsh is the leading area specialising in sheep husbandry with its internationally renowned rich pastures, but a few traditional orchards like the one below still retain their 'woolly lawnmowers'.

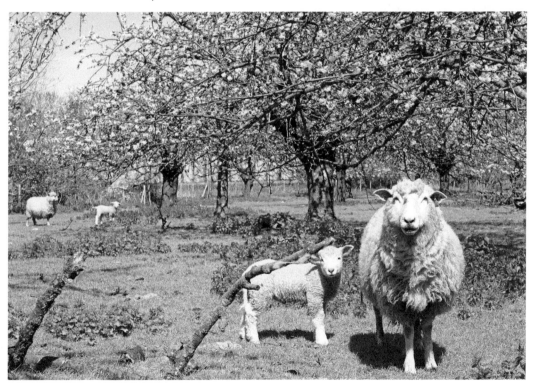

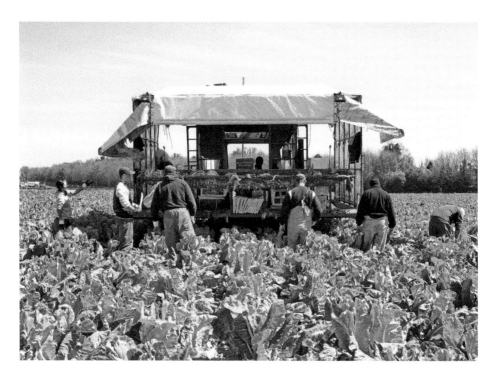

Cut Crops

Thanet with its superb mild maritime climate and fertile alluvial loam soil concentrates on the production of vegetable crops such as cauliflowers. On higher and poorer ground such as the dip slope of the North Downs another specialist activity known as chestnut coppicing takes place. However, the growing cycle is much longer with around fifteen years required for felled stumps to re-grow their strait timbers used in the local manufacture of fences.

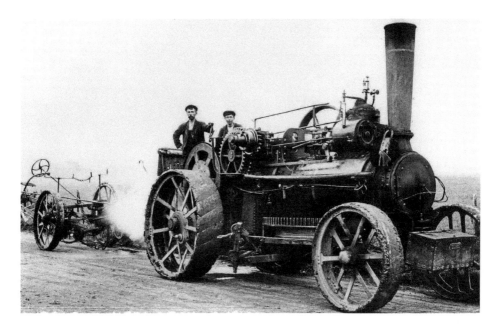

Changing Farm Machinery

Horses were common motive power on Kent farms until the Second World War but steam traction engines were introduced around a century ago to propel thrashing machines and ploughing rigs such as the one above. Today, high-tech tractors are employed to save labour costs on much larger field systems like the oil seed rape farm photographed below on the Isle of Sheppey.

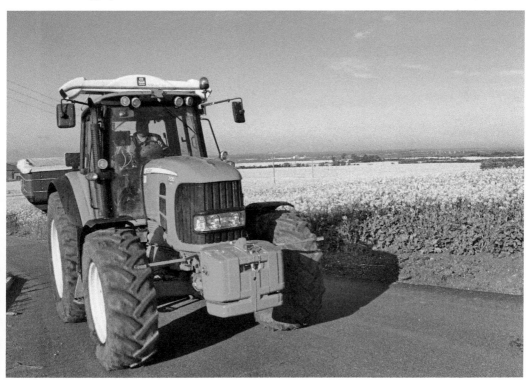

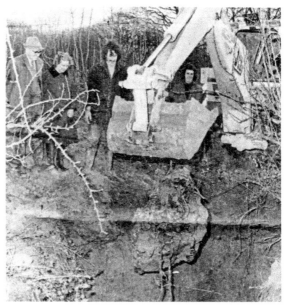

Battle of Britain Hurricane Crash at Upper Rodmersham

During the idyllic hot summer of 1940 the Battle of Britain was enacted over the skies of Kent. One casualty was a Hurricane, whose pilot, having bailed out over Maidstone, crashed into a productive cherry orchard at Upper Rodmersham. The author's father took a snapshot of the smouldering wreckage soon after he had avoided injury. In 1974 enthusiasts were permitted to recover the intact Rolls-Royce Merlin engine and the engine plate was retained as a family souvenir of this frightening incident, part of a proud epoch in British history.

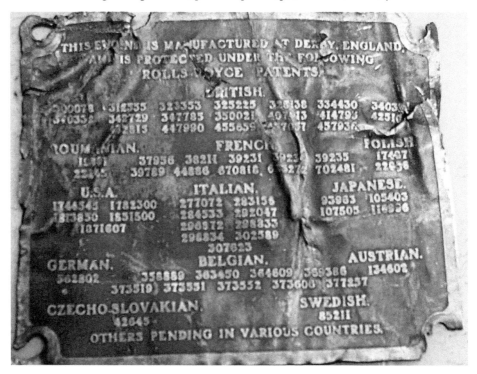

Battle of Britain Memorial Manston
One of the foremost, in every sense, airfields of the Battle of Britain was Manston near Ramsgate. A moving memorial can be found here with a poignant poem to 'Johnny in the Sky'. Nearby a free access museum exhibits a Spitfire and Hurricane along with many other interesting wartime relics.

Transport Links

Situated between the Continent and London, Kent has always been important for its transport links. The Romans built a major highway from Dover to London. In recent years a high speed railway has linked London via Ebbsfleet and Ashford to the Channel Tunnel near Folkestone. A tunnel also joins Essex to Kent along with the graceful Dartford Bridge shown below.

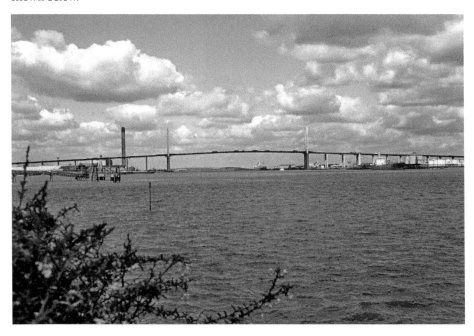

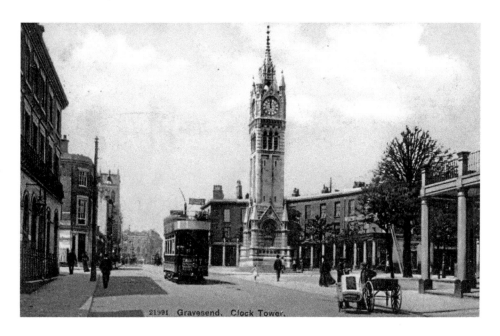

21991 Gravesend. Clock Tower.

Gravesend

Before the advent of railways Gravesend was an important coaching town. Travellers from London would prefer to travel by boat to here before taking a coach for their remaining journey, thereby avoiding potential robbery on heathland south of the metropolis. It also became a favourite destination for tourists in its own right first as a smart regency resort and then as a more populous Victorian playground for the masses.

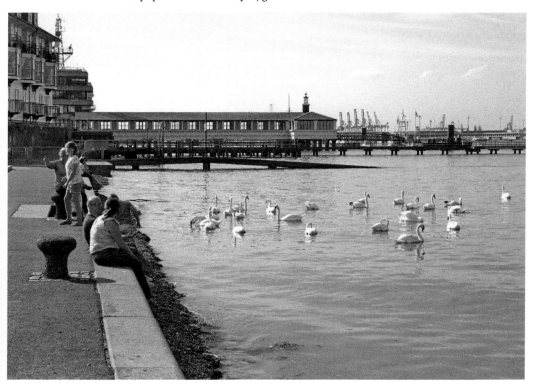

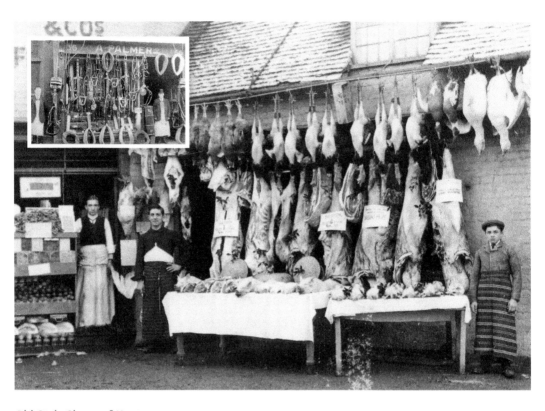

Old Style Shops of Kent

These old Edwardian shops are distinctive with their wares outside to attract buyers. The butchers are at Teynham, the harness makers at Sittingbourne and the shoe shop at Gravesend.

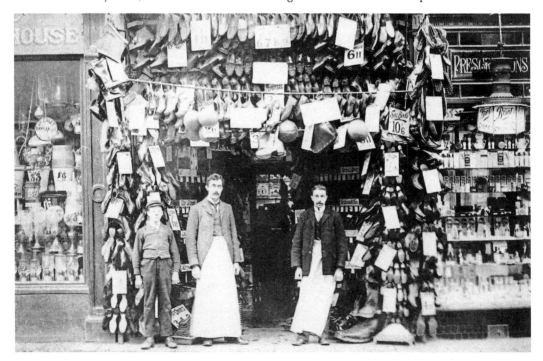

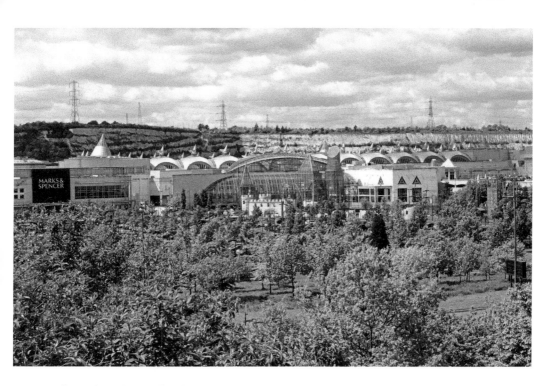

Modern Shopping Malls of Kent

With high streets in decline modern shoppers travel to large shopping malls like Bluewater and the Ashford Designer Outlet. Their futuristic architecture successfully contrasts with their surroundings, but above all they provide wide choice and adequate convenient parking facilities.

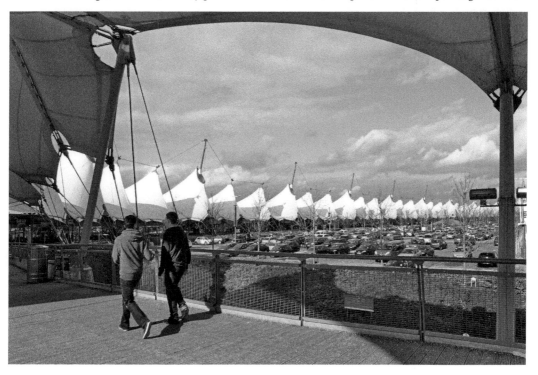

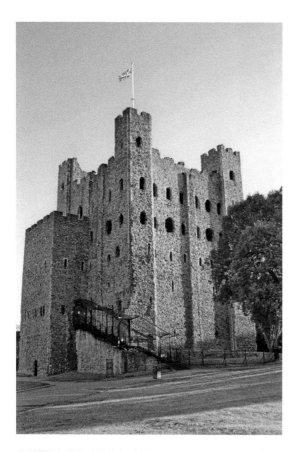

Rochester Castle
The Norman castle at Rochester was built to defend this vital crossing place over the Medway. Its most dramatic event was during the uprising of the Barons against King John when a siege led to the undermining and destruction of its defensive walls.

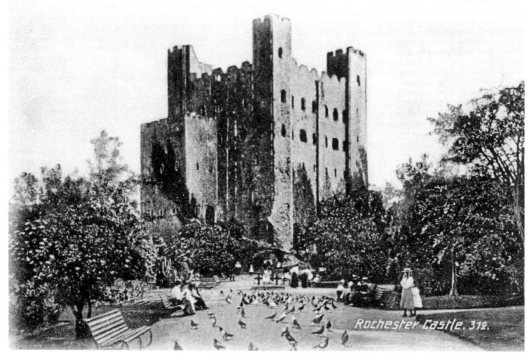

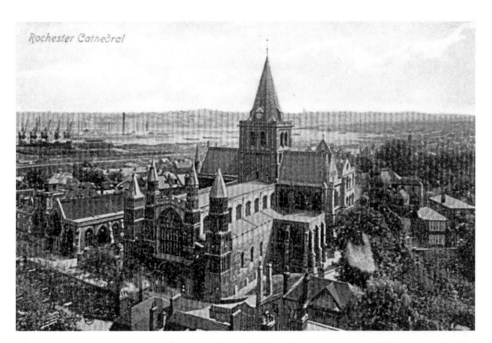

Rochester Cathedral

Rochester Cathedral

After the castle the Normans directed the construction of England's second oldest cathedral. Much of the work was designed by the talented architect Bishop Gundulf. Fire and neglect took their toll over the centuries that followed. However, during more recent times much restoration and alteration took place inspired by the famous Gilbert Scott.

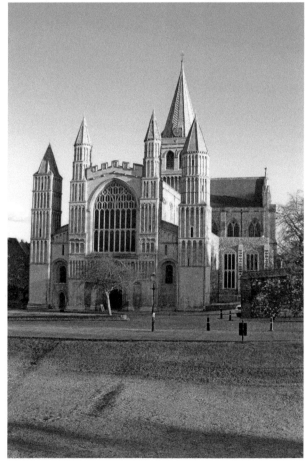

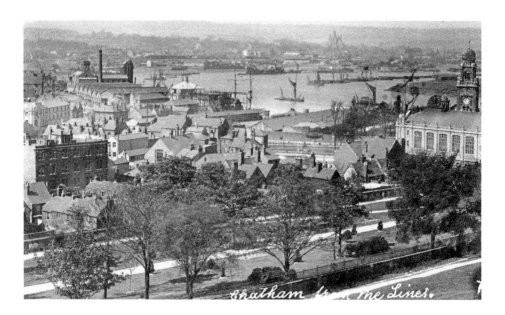

Chatham Dockyard

By Elizabethan times shore-based naval facilities at Rochester warranted the construction of Upnor Castle to defend against potential invasion forces. Its existence, however, did not deter a successful opportunistic late seventeenth-century Dutch raid. Thereafter the main servicing docks, repair and construction sheds and warehouses relocated inland slightly to Chatham. This erstwhile small fishing village became transformed into a vast industrial site reflecting the huge scale of the British Navy at its peak power. Now closed for defence activities it has been imaginatively transformed into a major tourist attraction.

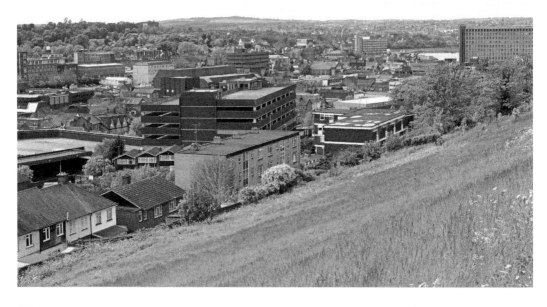

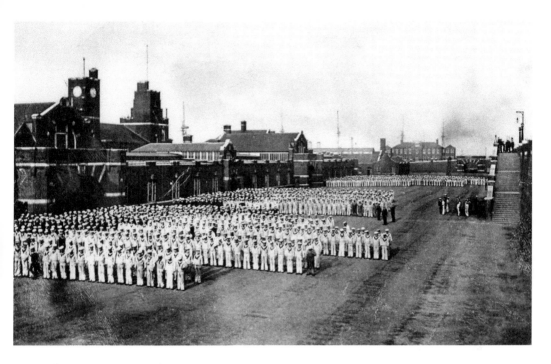

Military Strength at Medway

Even today the massive impact of large scale military installations and barracks around the Medway towns have left an important industrial legacy. The navy's vast force of sailors who were once stationed here is pictured on parade above while the intrepid Royal Engineers are shown below after an exercise to construct a temporary bridge over the nearby river.

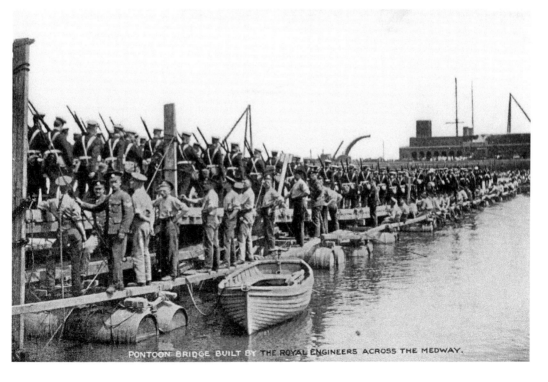

PONTOON BRIDGE BUILT BY THE ROYAL ENGINEERS ACROSS THE MEDWAY.

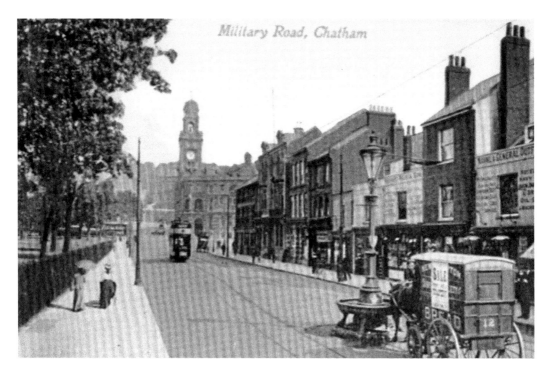

Military Road, Chatham

Chatham Town Hall

The large distinctive town hall clock tower has looked down on many changes to this bustling town over the years. Horse-drawn vehicles have been succeeded by trams, buses, lorries and cars. To confuse present road users, traffic flows have recently been redesigned.

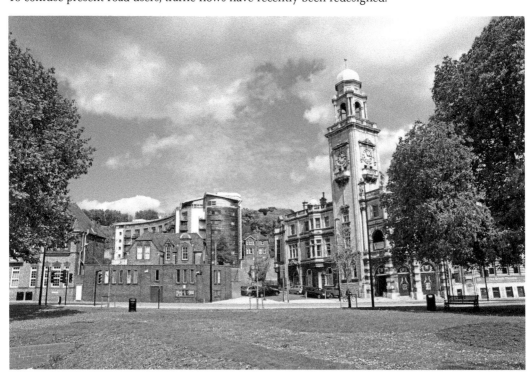

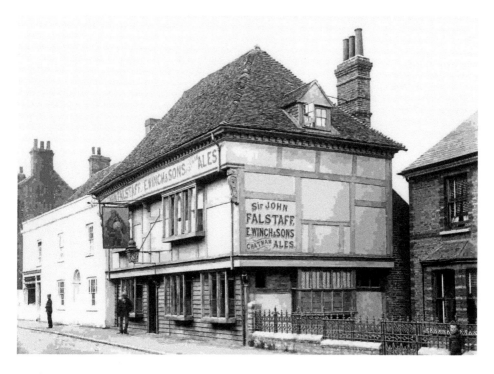

Watling Street

Many changes have taken place along the old Roman road across north Kent. Following fire damage the public house once known as the George above has been converted into two houses and is still recognisable. However, the old crossroads without traffic lights pictured below at Key Street has become an enormous interchange between the A2 and A249 with a roundabout and a deep underpass.

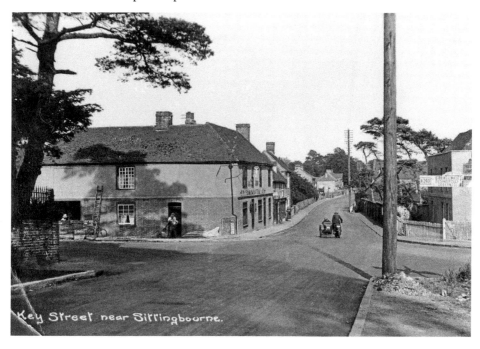

Key Street near Sittingbourne.

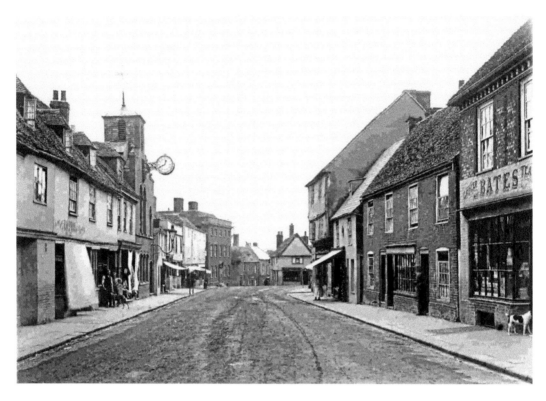

Milton Regis

Milton Regis was once the major town between Canterbury and Rochester as its abbreviated 'middle town' name implies. Since then it has been subsumed into the nineteenth- and twentieth-century expansion of its neighbour Sittingbourne. Nonetheless, its ancient High Street, comprising many historically listed properties and now a conservation area, has lost little of its ancient charm.

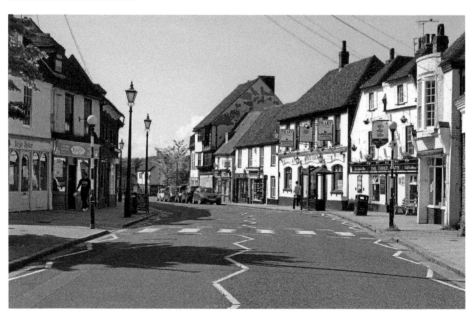

Thames Sailing Barges

Before the advent of large articulated lorries, Thames sailing barges ferried heavy bulky loads around the Kent coastline. They were particularly efficient for conveying building materials such as bricks and cement from manufacturers on the northern shoreline to metropolitan civil engineering contractors. Return loads often consisted of London refuse which was recycled either as manure for the fields or an ingredient in brick making. The old and new images juxtaposed here are Milton Creek boats with cement and brick producers adjacent and a beautifully restored vessel tied up on a buoy in the reach of the Thames at Gravesend.

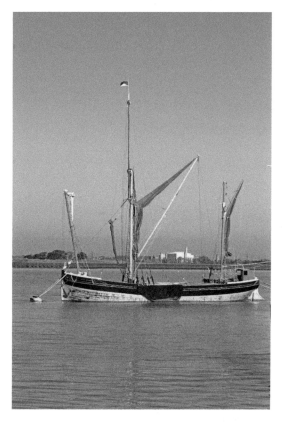

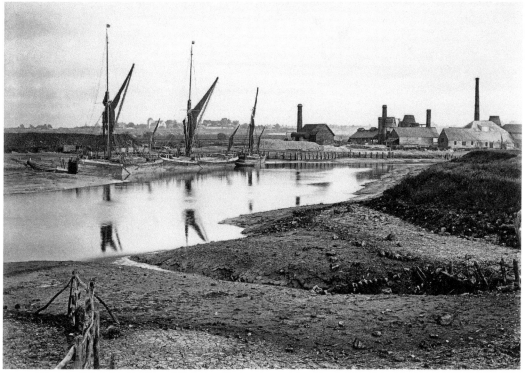

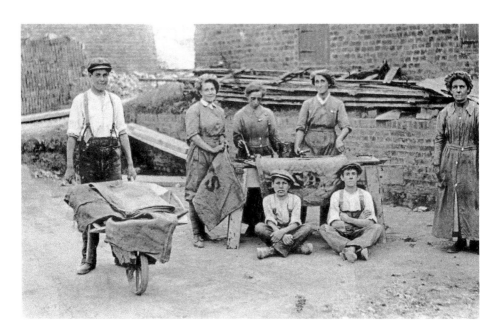

Brick Makers

Brick and cement manufacture are traditional heavy industries of Kent owing to plentiful supplies of chalk and brick earth. These raw materials often overlaid each other near the earth's surface thus facilitating open-cast mining extraction. Deep derelict chalk pits such as those at Bluewater are easily identified, but more shallow brick earth sites can be more difficult to discern from slightly lower field patterns. The pictures on this page show a team of workers from the renowned Smeed Dean firm marking old hessian sacks with the initials SD while a contemporary Faversham craftsman is at work moulding a decorative piece.

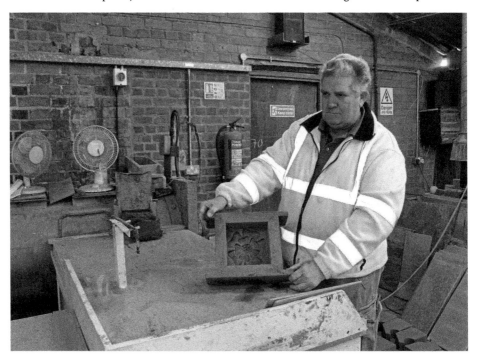

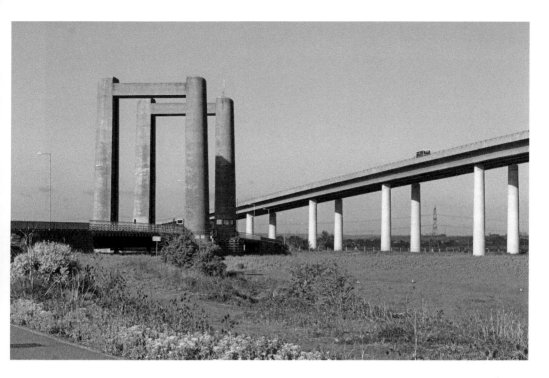

Kingsferry Bridge

Originally the Isle of Sheppey was connected to the mainland by a boat ferry. Now the modern rail and road concrete bridges cutting the skyline above replace the rackety old one below which was often closed due to damage from freighters carrying logs to the paper mills at Ridham Dock.

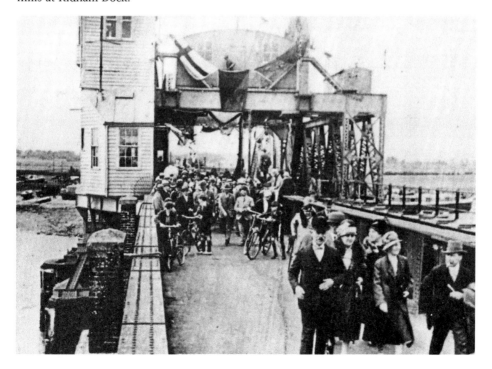

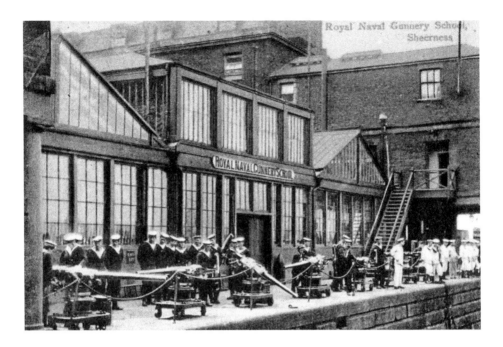

Sheerness Dockyard

The Royal Navy built extensive forts and repair services at Sheerness after the scare of a brief raid by Dutch enemies in the late seventeenth century. The picture above shows cadets practising gunnery drills when the establishment was at its zenith a hundred years ago. Below this substantial regency terrace of officers' quarters, which is a valuable architectural legacy of the Royal Navy's stay, is to be mercifully restored by the Spitalfields Trust whose foresight often overrides short term local authority planners' limited vision.

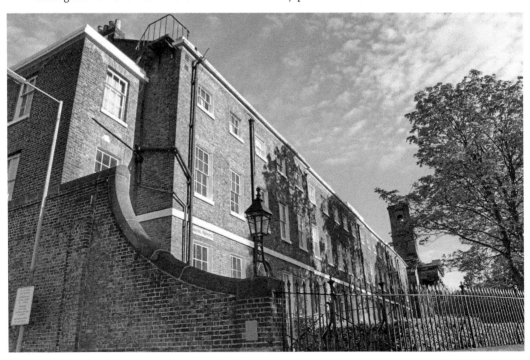

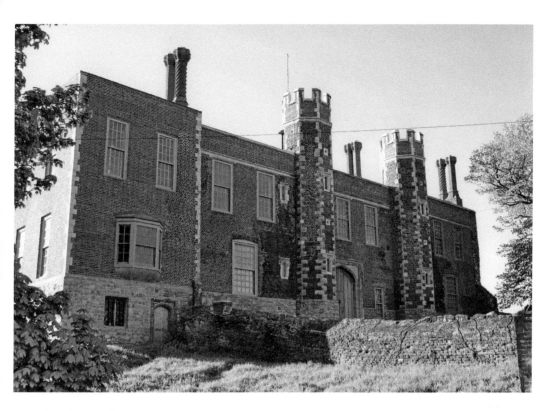

Shurland Hall

Shurland Hall has been another suitable subject for expert and sympathetic restoration by Spitalfields Trust. This ruin has been transformed back into a desirable residence – one that was once used by Henry VIII while honeymooning with his second ill-fated wife Anne Boleyn. The Isle of Sheppey has many other royal connections in particular Edward III's wife Philippa, who had a castle at Queenborough. At its eastern extremity pioneer aviators made their early fitful attempts at flight from Musgrave Manor.

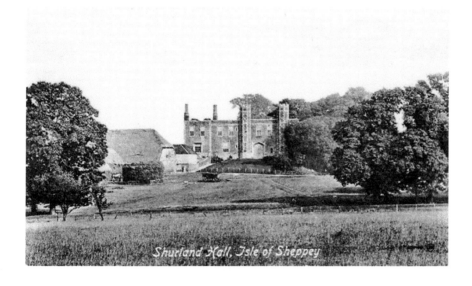

Shurland Hall, Isle of Sheppey

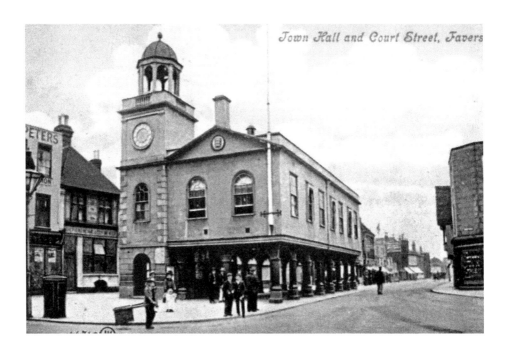

Faversham

There has been little change over recent years to Faversham town hall. It is an Elizabethan structure with Regency additions located at the centre of this fascinating town. The town was pre-eminent in early medieval times due to its massive abbey. Later as the cradle of the gunpowder industry it was of vital importance to England's defences. Today, the town is much admired for its beautifully preserved listed buildings lining its quaint picturesque streets.

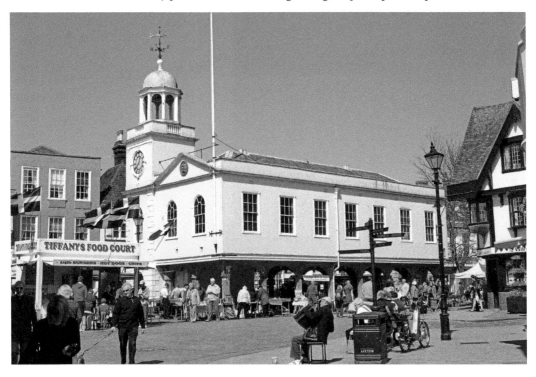

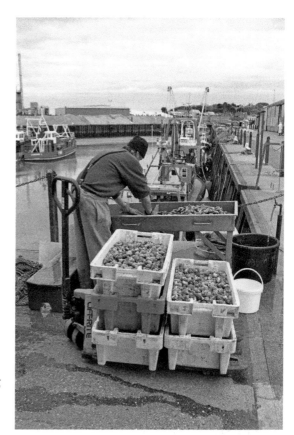

Whitstable Harbour
From Roman times Whitstable has been famous for its shellfish industry. Working fishing boats operate from the harbour which is surrounded by fishmongers, packers and associated restaurants.

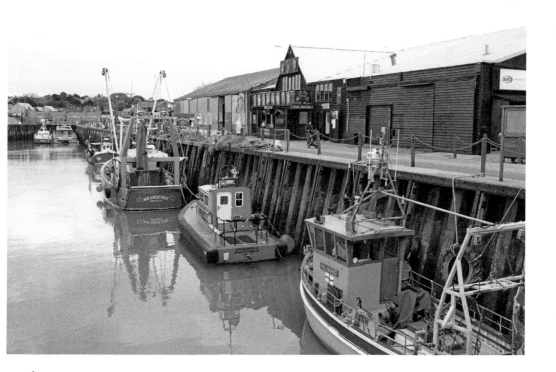

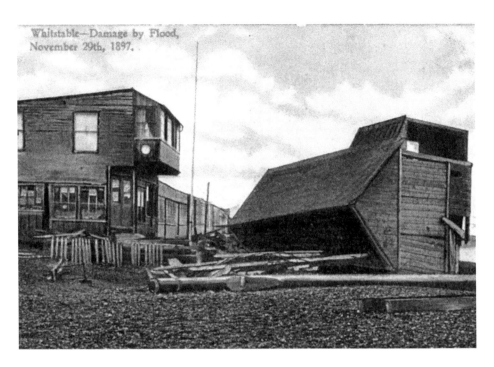

Whitstable—Damage by Flood, November 29th, 1897.

Whitstable

These old images on this page reflect Whitstable as an ordinary fishing town at the turn of the last century. Today it has been described as 'Notting Hill by the Sea' as affluent Londoners have colonised this resort, restoring old artisan cottages and patronising the many specialist boutique style shops and food outlets which have evolved to serve them. The local authority, too, has responded well to this gentrification with sympathetic schemes for urban improvement.

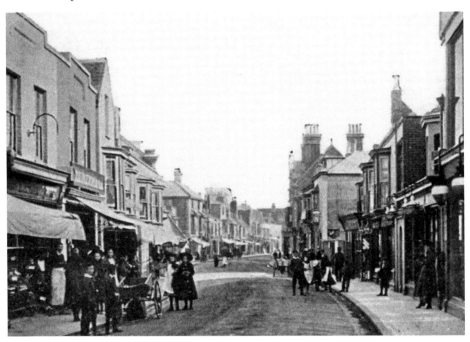

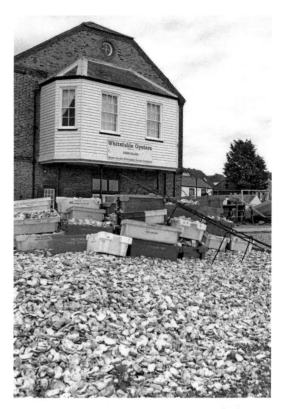

Fish Restaurants, Whitstable

Oysters are a staple fare at the best Whitstable restaurants. Wheelers in the High Street with its unique paintwork is world famous. The scale of consumption in the large restaurant on the seafront can be gauged from the piles of empty shells strew across the adjacent beech.

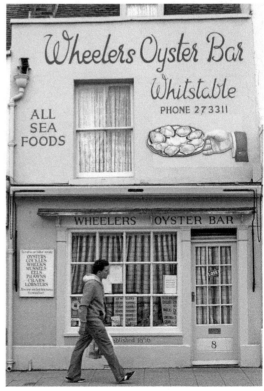

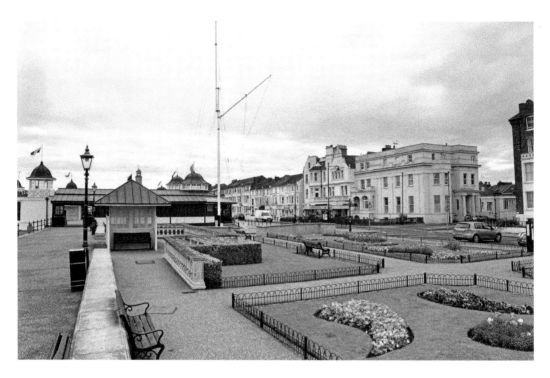

Herne Bay

Herne Bay developed from small shipping and farming community to become a popular Victorian seaside resort. London businessmen saw its potential, building a pleasure pier and a benevolent lady donor gifted the world's first free-standing public tower clock. With the growth of foreign holidays tourist numbers have substantially declined, but the municipal authorities have encouraged revival with restoration of the Victorian gardens above and other council buildings.

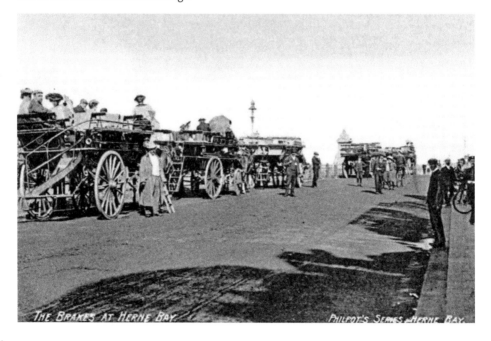

THE BRAKES AT HERNE BAY. PHILPOT'S SERIES, HERNE BAY.

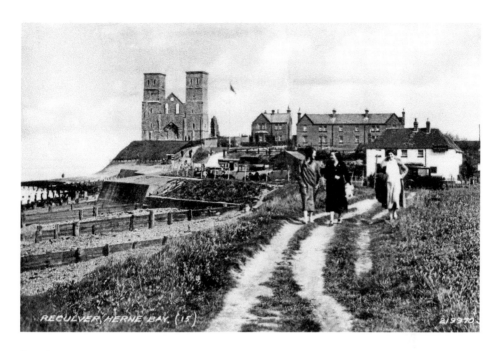

Reculver

Eastwards of Herne Bay lies Reculver, which was once a thriving town in the Middle Ages. Its importance was related to its position at the mouth of the Wantsum River which once separated Kent from the Isle of Thanet. The Romans built a fort here and when they left English shores Saxons took over the site and built both a fort and a monastery. The two distinctive towers are notable landmarks for sailors known as the twin sisters. During the Second World War, Barnes Wallis successfully tested his revolutionary bouncing bomb along the seashore here.

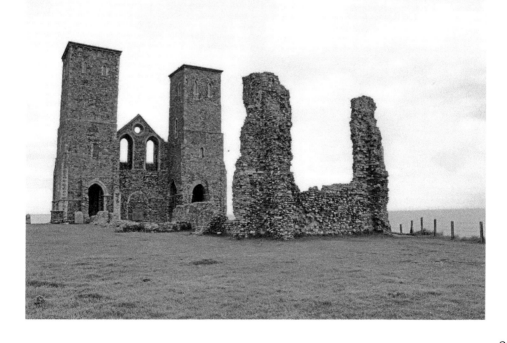

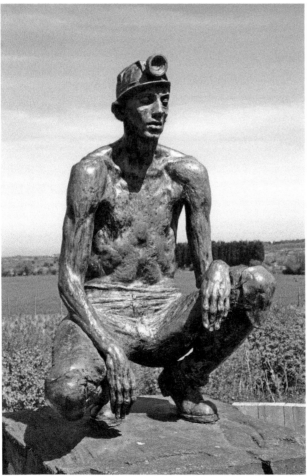

Memorial to Kent's Coalminers
The Kent coalfields were developed after this valuable fuel was discovered by accident whilst Victorian engineers were digging a prospective channel tunnel. All mines are now closed, but a memorial to those men who lost their lives has been erected at Fowlmead Country Park. This is the third time that this sculpture of a gaunt waiting miner has been moved. Originally it was at Richborough power-station were coal was incinerated to produce electricity and then to the front of Coal Board offices on Dover seafront.

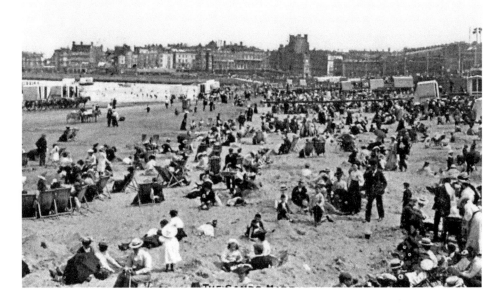

Margate

Margate was one of the pioneer seaside resorts for bathing, and the view above shows how popular it became. Today you will notice the splendid sandy beach is relatively deserted. Once a favoured place for the artist Turner to stay because of its exceptional light from its open northerly skies, a modern art gallery named after him is successfully revitalising visitor numbers.

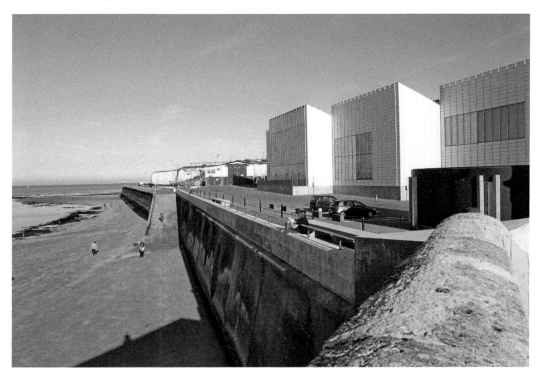

4 KINGSGATE. — Captain Digly Hotel. — LL

Captain Digby

The Captain Digby is perched perilously above the chalk cliffs at Joss Bay near Broadstairs. You will see from these pictures that the flint elevations of this prize-winning pub and restaurant have changed very little over the past hundred years.

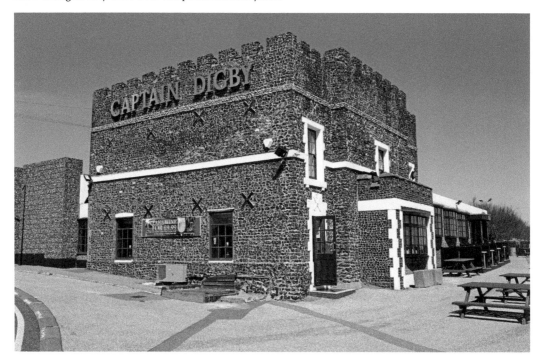

40

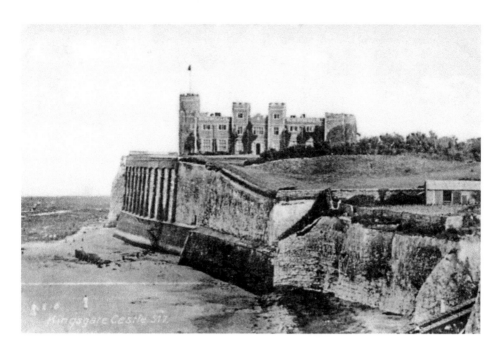

Kingsgate Castle

Kingsgate Castle was built for Henry Fox, 1st Baron Holland, in the 1760s upon a most spectacular site overlooking the ocean at the very extreme south-east corner of Kent. Kingsgate derived its name from a landing here by Charles II. Later it became the residence of a very distinguished Victorian polymath called John Lubbock. He came from a wealthy banking family, but his interests and abilities covered a wide field including archaeology, natural science and politics. Eventually he was ennobled and took his title 1st Baron Avebury after the prehistoric stones which he purchased for their permanent preservation.

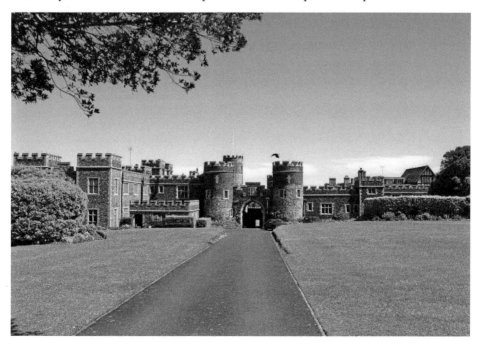

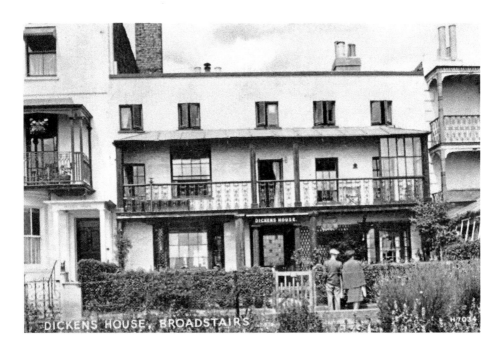

Broadstairs

Broadstairs is an exquisite coastal resort between Margate and Ramsgate. Its name derives from stairs which led from the beach to an ancient religious shrine. Much later Buchan named his novel *The Thirty Nine Steps* on a more modern set of stairs he encountered here. It is easy to appreciate from the serene unchanging vista below that the town is known 'as the jewel in Thanet's crown'. Charles Dickens loved to visit and was inspired to write *David Copperfield* while staying at Bleak House. A museum of his artefacts can be found in the old house pictured above near to the fabulous Morelli's coffee bar and ice cream parlour which is a pristine example of 1950s trends.

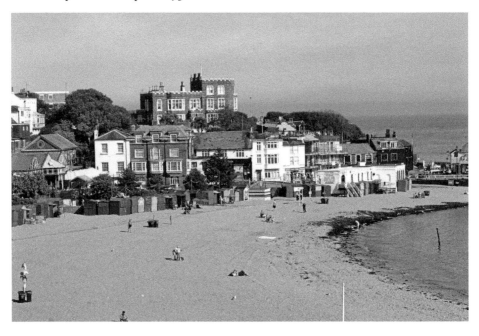

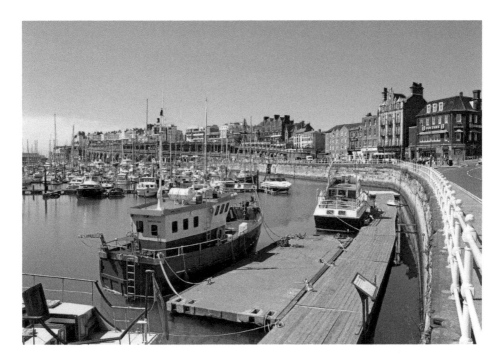

Ramsgate

Ramsgate was a favourite watering hole for Regency and Victorian visitors who were warming to the fashion for sea bathing. It was also a convenient port for embarkation to the Continent. Today, its splendid harbour with berths for 700 pleasure boats is a major feature of the town. The respected Temple Yacht Club has its headquarters here and therein hangs a portrait of a past commodore Sir Edward Heath. He was born in the adjacent town of Broadstairs in 1916 and attended Ramsgate's Chatham House School before Balliol College Oxford and eventually became Prime Minister.

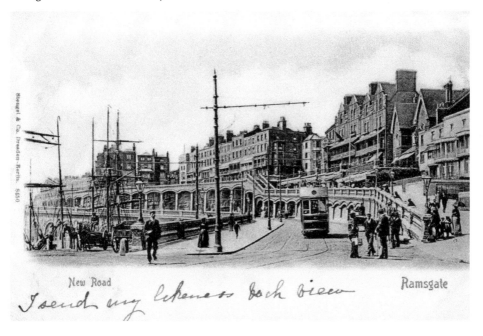

New Road Ramsgate

I send my likeness back view

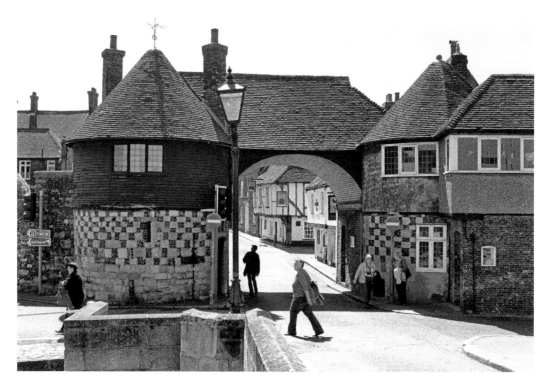

Sandwich

Sandwich is an historical town which was of some consequence when it was a Cinque Port at the head of the Stour River. Since medieval times, however, the coastline silted up and the sea is now two miles away. St George's golf course is of world class standard and has been used for the UK open championship. Also of note is the large site of pharmaceutical firm Pfizer, which is threatened with closure. It was here that Viagra, the drug for erectile dysfunction, was discovered and patented.

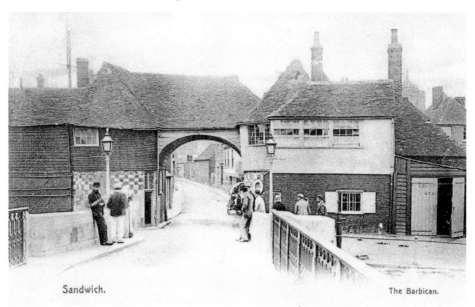

Sandwich. The Barbican.

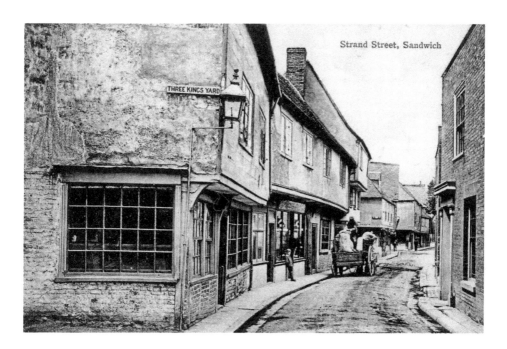

Strand Street, Sandwich

Strand Street, Sandwich

Strand Street, Sandwich, is comprised of many listed buildings but the practise of exposing the framework of these timber-framed structures has waned. Elsewhere in Kent at Provender the architect Ptolemy Dean, in his designs for restoring Provender, has reversed this regrettable fashion. The majesty of these quaint old buildings is best appreciated when contrasted with the plainer plastered walls as shown in the older picture here.

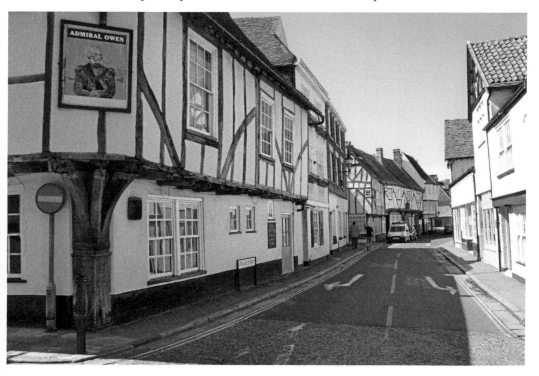

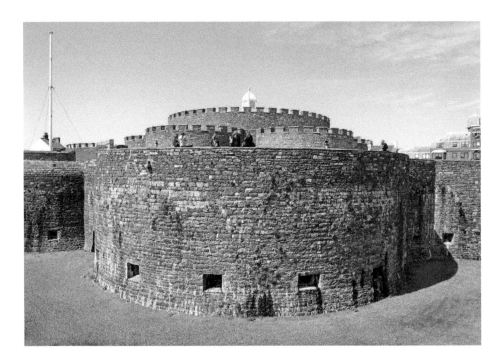

Deal

Deal was a strategically important point of defence on the Kent coastline close to France and alongside the part of the Channel known as the Downs where ships could anchor in safety. Henry VIII ordered the erection of a prominent concentric circle fort which remains perfectly restored today. Its inhabitants were mostly engaged in maritime pursuits such as fishing. Some were infamous for being involved in the prevalent smuggling activities which flourished all along Kent's coastline during the eighteenth and nineteenth centuries. At present Deal has developed into a smart, quiet backwater of civilised and cultural excellence.

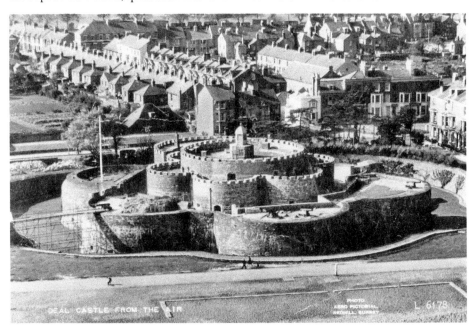

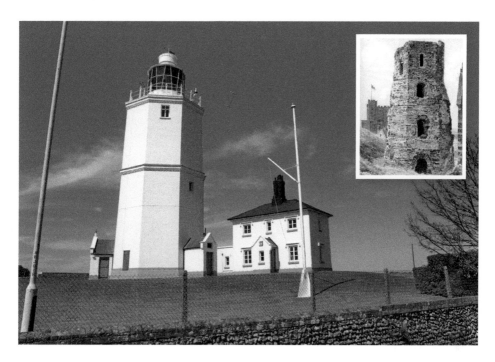

Lighthouses

The old lighthouse at North Foreland is pictured above. It is very similar to its neighbour the South Foreland near Dover. Here the Romans built two Pharos lighthouses on opposite cliffs at the entrance to the old harbour. An artist's depiction of the surviving one is reproduced here. However, it is now used as a bellower for the nearby church. Below, lighthouses which marked Dungeness to mariners are shown amid their unusual pebbled landscape.

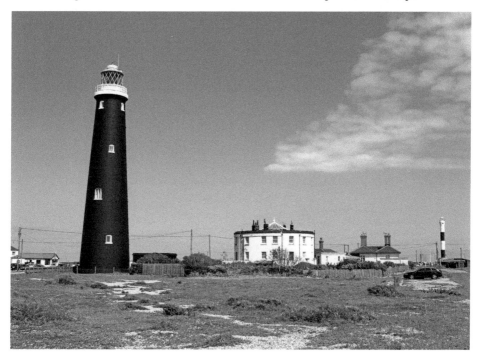

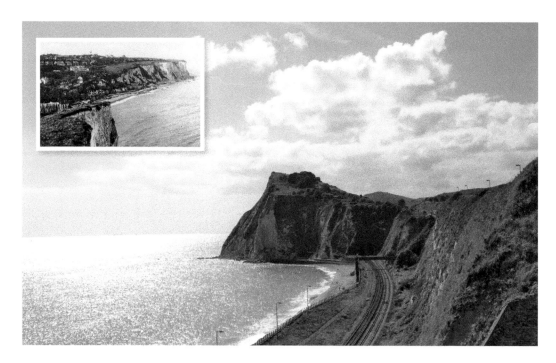

White Cliffs

The white cliffs of Dover are forever sentimentalised by Vera Lynn's wartime ballad. However, they have long been iconic beacons of hope and freedom inspiring expatriates returning to their native shore. The most famous is Shakespeare cliff at Dover which rises steeply from the sea and derives its name from a tragic scene in the play *King Lear*.

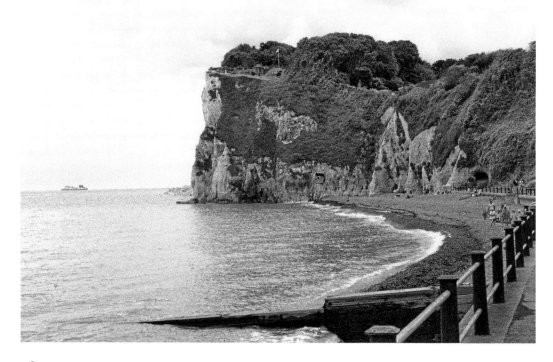

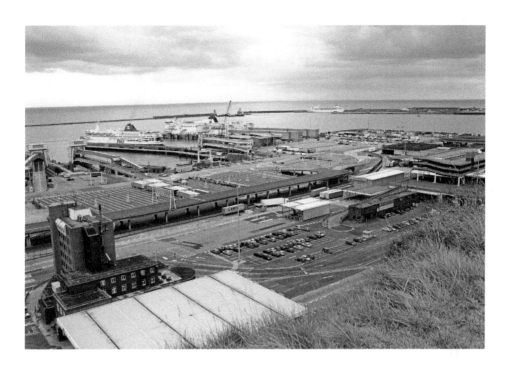

Dover

Dover's modern significance to Kent and the whole country is its busy port serving Continental travellers. The picture above shows terminal buildings and waiting ferries with a glimpse of the long harbour wall which encompasses a square mile of protected waters. Below is an instantly recognisable painting of the impregnable castle silhouette towering above the pleasure beech and elegant buildings. Many of these smart Victorian hotels were destroyed and replaced following wartime bombardment when this became known as Hellfire Corner.

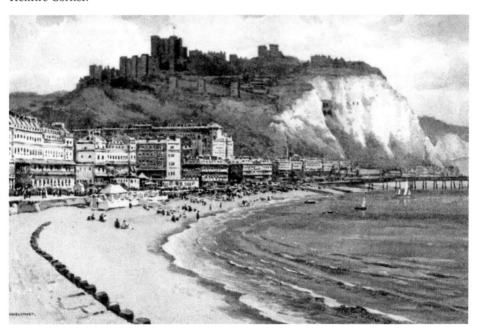

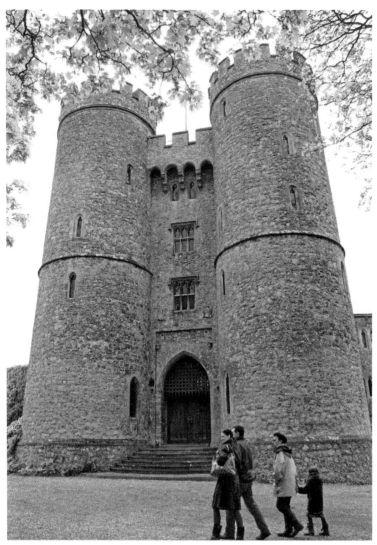

Saltwood Castle

Saltwood Castle was the location where the assassins of Thomas Beckett met before riding off to Canterbury to commit their heinous crime. After ownership by the Deeds family it was purchased by Sir Kenneth Clark who was the art connoisseur famous for his television programme *Civilisation* and then to his equally well known son Alan Clark, who pursued a career as a writer, politician and classic car expert.

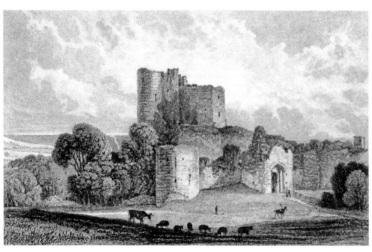

Saltwood's Treasures

The delightfully charming widow of Alan Clark is captured by this photograph of herself graciously signing a copy of her husband's book *Backfire*. This entertaining volume is a collection of articles written for motoring magazines and other musings on classic cars. Below is a peak into the private garages housing a wonderful collection of vintage vehicles with stalwart gardener Brian alongside a much loved no nonsense Rolls-Royce Silver Ghost.

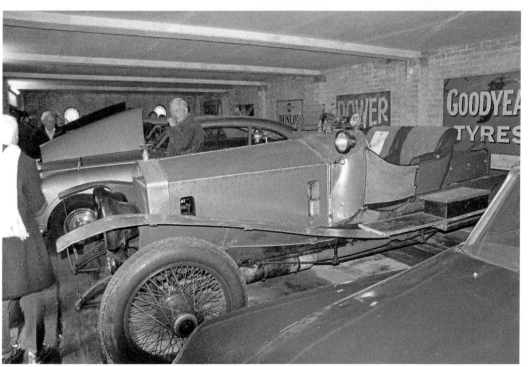

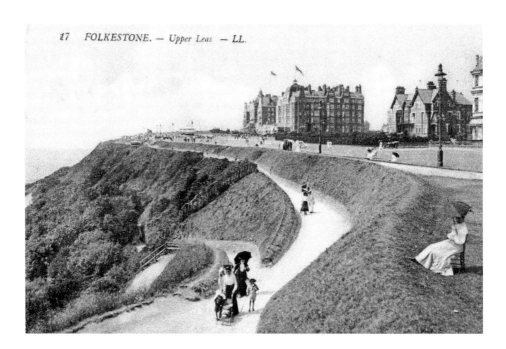

Folkestone

Like many Kent coast holiday resorts Folkestone started life as a small fishing village and Channel port. However, the early arrival of a railway line in 1843 had a tremendous impact on Folkestone. By the Edwardian era it had become an elegant destination for prosperous pleasure seekers. The grandeur of its hotels reached its apogee with the Grand Metropole which was a favourite yet discrete destination for Edward VII and his mistress Alice Keppel, grandmother of Camilla Duchess of Cornwall.

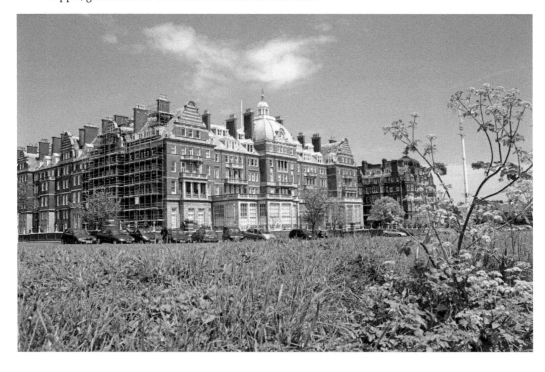

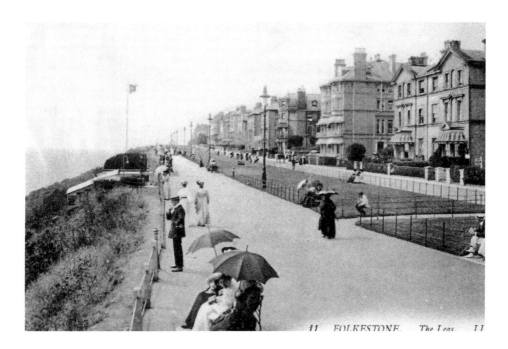

11 FOLKESTONE The Leas 11

The Leas, Folkestone

Bracing walks along the Leas provided good constitutional exercise for over-indulged guests at nearby hostelries. Today, the area retains its smartness with a well maintained bandstand and immaculate formal garden beds. The picture below illustrates the healthy aspect of this recreational area with gusty breezes and clear pure seawaters lapping its clean beach.

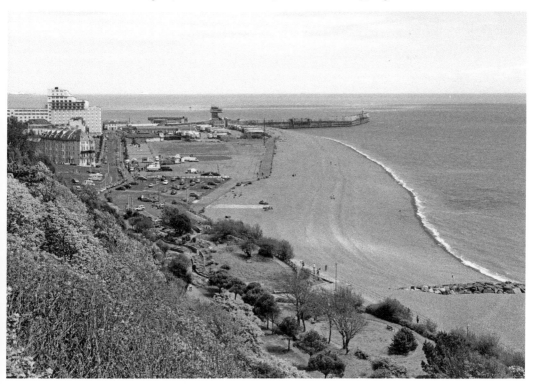

Hythe

Hythe is one of the Cinque Ports and derives its name from an ancient form of the word haven. Like Sandwich the erosion, transposition and deposition of silt along the coastline has left Hythe far from present shores. Nonetheless, the town has a pleasant atmosphere with the Royal Military Canal and nearby Martello Towers as reminders of its past significance to the defence of the realm. The town hall, with its plain portico, was built *c.* 1790. Within, it surprisingly contains a fireplace designed by the illustrious Adam brothers.

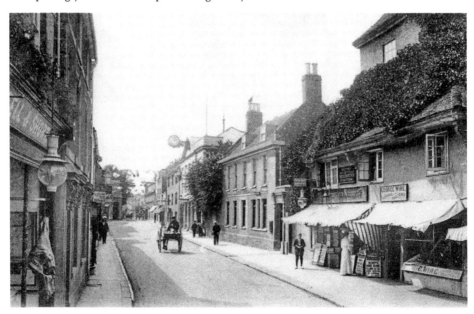

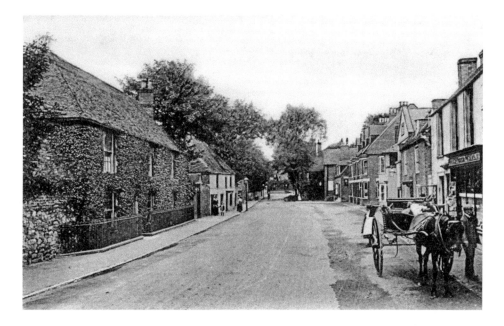

New Romney

New Romney is something of a misnomer as it is just as old as its neighbour, Old Romney. It is the centre of population for the fertile sheep-breeding area of Kent known as Romney Marsh. Past storms and movement of shingle and silt have, like other Cinque Ports, left this merely a small town. However, it has many old and interesting shops and houses lining its main thoroughfare.

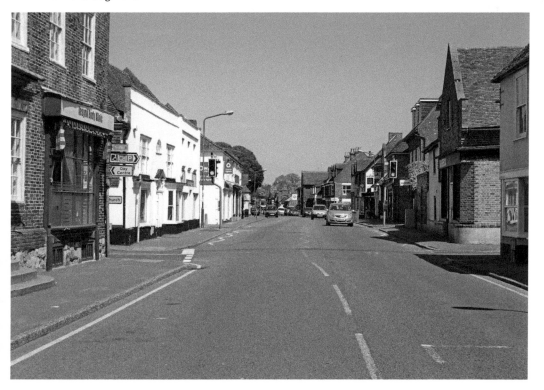

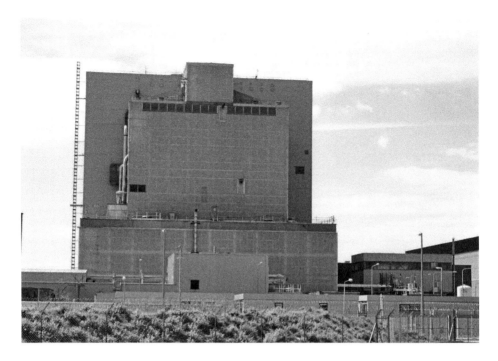

Dungeness

No greater contrast in scale, style or solidity of construction could be made of these two unusual buildings at Dungeness. The angular concrete mass is part of the nuclear power station which has closed while the pretty hut was a retreat for the late artist Derek Jarman. Its side elevation is embellished with extracts from John Donne's poem 'The Rising Sun', while the garden is acclaimed for its stylistic genius of mixing flotsam and native seaside loving plants together.

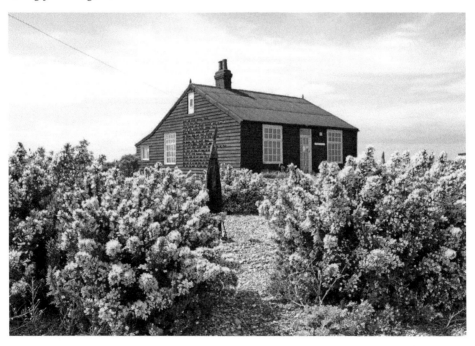

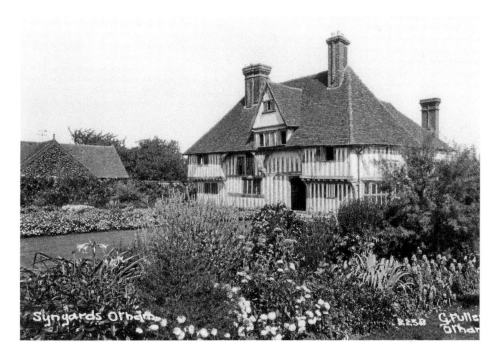

Timber Framed Houses of Kent

Kent has a rich legacy of half-timbered houses. Their endearing style and warmly comforting appearance have become almost a signature logo for the county's architectural heritage. The Wealden Hall, exemplified in the old postcard image here, has remained a durable home for present generations who now pursue more varied occupations than its original yeomen farmers. The colour photograph shows a home near Selling of the infinite variety of such well-preserved residences constructed from local materials of oak and chalk.

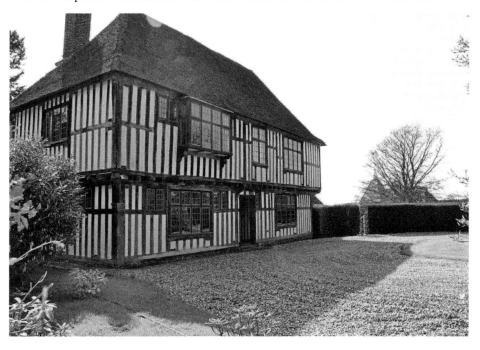

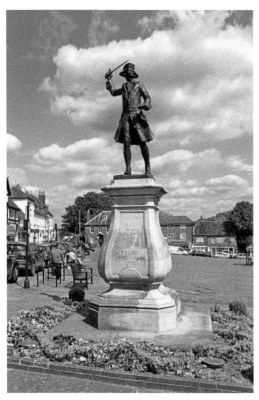

Quebec House, Westerham
The well-preserved childhood home of General James Wolf at Westerham, west Kent, is open to the public. It is managed by the National Trust and attracts many visitors. A memorial statue of this career soldier, who surprised and defeated French forces after stealthily scaling the cliffs of Quebec, is placed high on the village green with his hand held triumphantly aloft brandishing a sword.

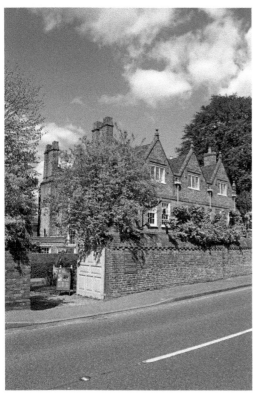

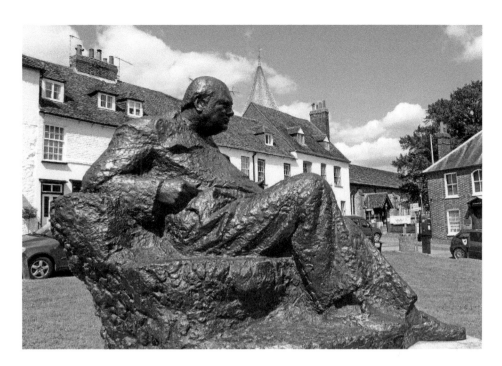

Chartwell

Voted the greatest Briton by a modern television audience, Sir Winston Churchill's powerful force of character is captivated in this dramatic sculpture on the Village Green, Westerham. A brilliant writer, soldier and statesman, this colossus of the twentieth century was also no slouch at selecting a country residence. His beloved Chartwell is pictured here from an unusual angle atop the North Downs with unrivalled views of the distant Weald below. How often in his declining years, the old warrior must have sat pondering before his carp pond on the mutability of fame and the span of eternity!

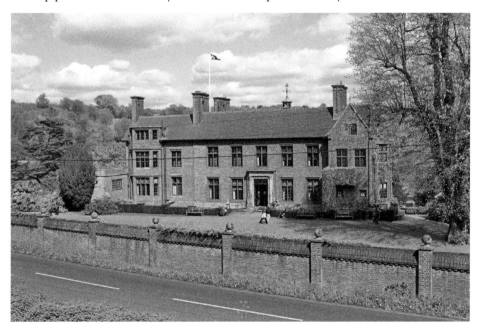

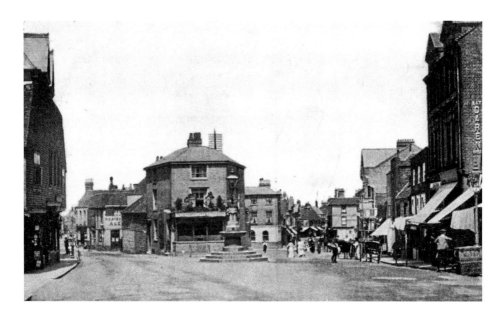

Sevenoaks

Sevenoaks is so called after a group of trees planted in Knowle Park. This mansion is home to the Sackville-West family and the town not only derives its eponymous title from here, but also its economic growth. At present the area is a prosperous dormitory commuter area with the rocketing prices reflecting its convenient proximity to the capital. Cricket using three stumps for a wicket was first practised here in the eighteenth century. Furthermore, this quintessentially English sport was said to have originated nearby at the large village of West Malling, as recorded on the £10 note.

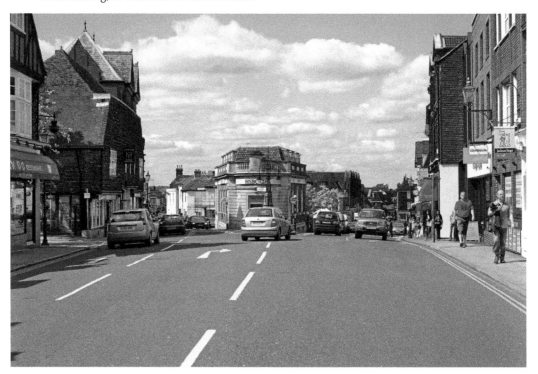

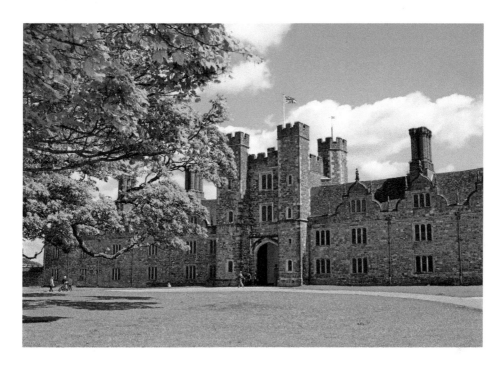

Knowle House

Knowle House is a vast enchanting pile set within a 1,000-acre deer park. It is known as a calendar house because of its 365 rooms, 52 staircases, 12 entrances and 7 courtyards. This spectacular backdrop has been used for many film locations and is particularly famous for settings used by the Beatles. Virginia Woolf's lover, Vita Sackville-West, lived here in the early twentieth century, and Woolf's novel *Orlando* is based here. Amongst an interior of priceless art and antique treasures there is the original Knowle sofa with its distinctive high sides designed to combat draughts.

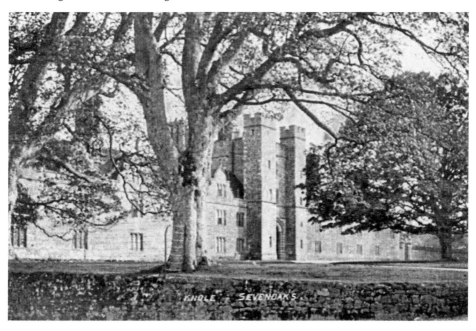

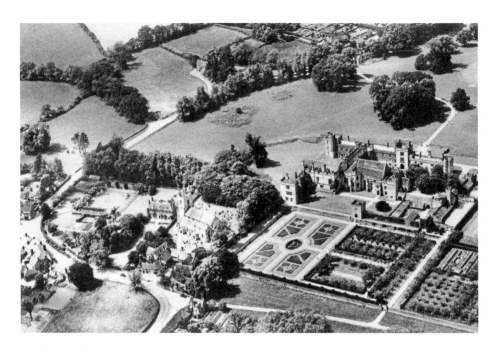

Penshurst Place

Penshurst Place near Tonbridge is an impressive example of medieval architecture. Constructed as a nobleman's residence its design was at a turning point when such buildings were no longer merely military fortresses. Owned for centuries by the Sidney family it boasts one of the oldest private gardens in England.

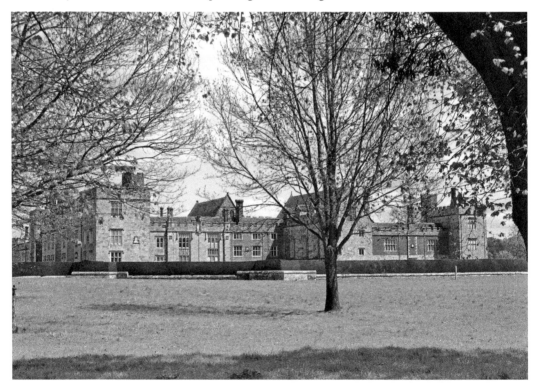

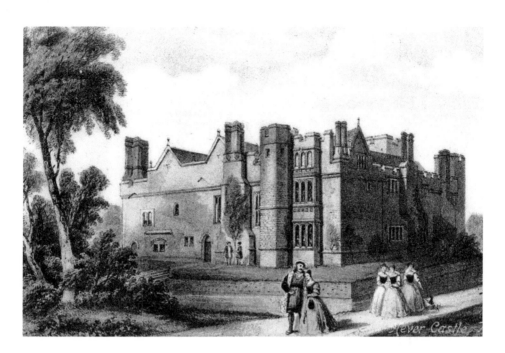

Hever Castle

Hever Castle near Edenbridge was the childhood home of Anne Boleyn and is where Henry VIII came to court her on many occasions. Subsequently it was given as a part settlement to his fourth wife Anne of Cleaves. The fabulously rich American Waldorf Astor purchased the poorly maintained property in the 1900s and lavished much expenditure on its restoration, building a Tudor style annex of cottages for his large retinue of domestic staff and garden enhancements which included a large lake and an Italianate collection of sculptures and ornaments. This historic castle is now open to the public and hosts regular events in its attractive setting.

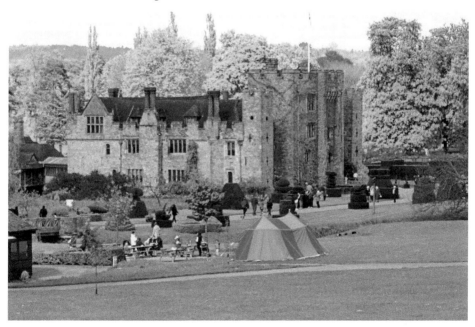

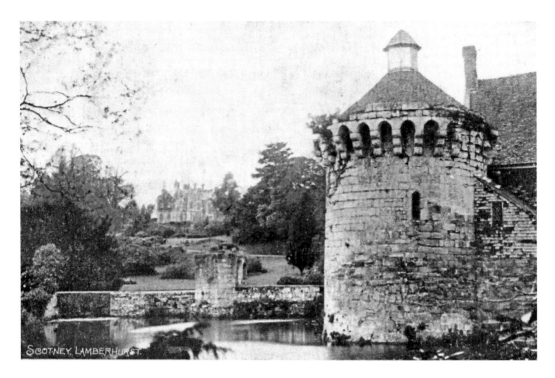

SCOTNEY, LAMBERHURST.

Medieval Moated Manor Houses

Scotney Castle and Ightham Mote are two examples of medieval moated manor houses. The former near Lamberhurst is now the centrepiece of a celebrated garden in the picturesque style and was superseded by a new mansion around 1840. Ightham Mote near Sevenoaks, however, is much lauded by Pevsner, the architectural historian, as an unmolested survivor of this type of manor house which focused inwards towards its courtyard.

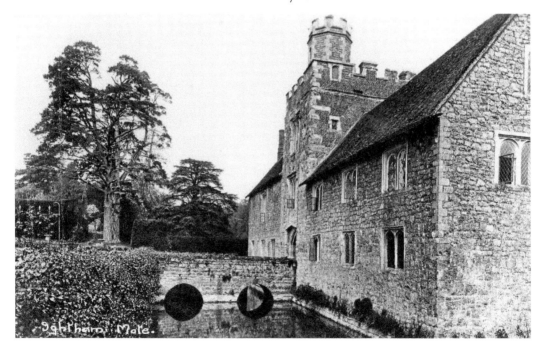

Ightham Mote.

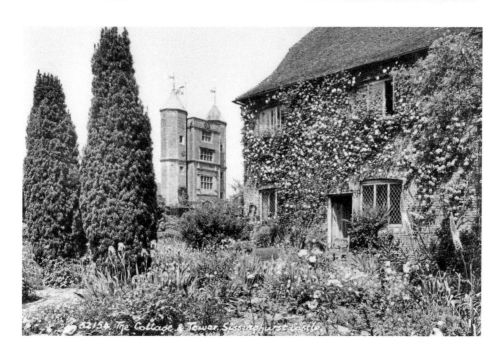

Sissinghurst Castle

Poet and gardening writer Vita Sackville-West instantly fell in love with this property near Staplehurst when she viewed it as prospective buyer in the 1930s. With her author and diplomat husband Harold Nicholson, she transformed it into one of the most loved and admired gardens in the world. Their innovative designs incorporated a series of outdoor rooms with different areas divided by high hedges or mellow brick walls.

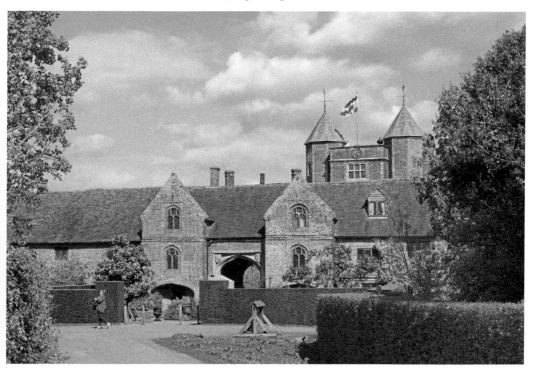

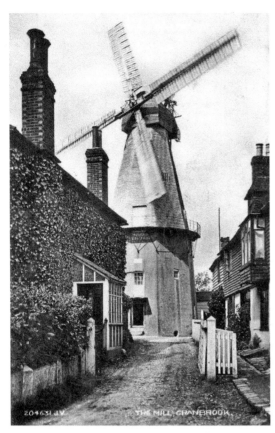

204631 J.V. THE MILL CRANBROOK.

Cranbrook

Cranbrook is a pleasant small town on the Maidstone to Hastings road. Its economic history is linked to its prominence as the centre of the medieval Wealden cloth industry and its proximity to iron making at Bedgebury. Of a great number of water and windmills the Union Mill pictured here remains beautifully restored and in working order. Built for Henry Dobell in 1814 it was subsequently run by a union of his creditors after he went bankrupt five years later.

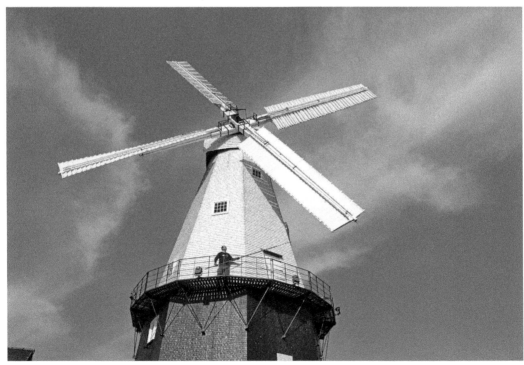

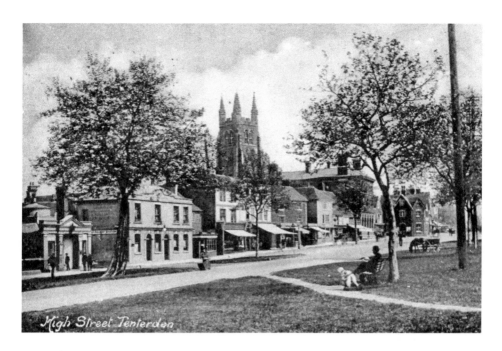

High Street Tenterden

Tenterden I

Tenterden is a thriving country town with an exceptional ambience from its peaceful tree-lined streets and pretty period properties. The wool trade and its role as a Cinque Port, before the sea retreated southwards with silt marshes becoming firm pasture lands, contributed to its wealth. It is now a favourite destination for tourists seeking antique shops, specialist boutiques and cafés to refresh themselves.

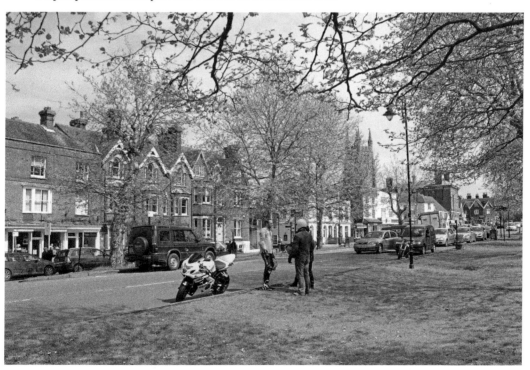

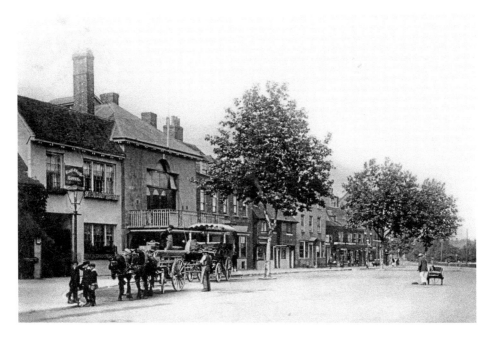

Tenterden II

Tenterden's town hall with its railed balcony looks out on a peaceful scene despite a century of changes elsewhere in Kent. Indeed, the scene above could be a film still from a spaghetti western!

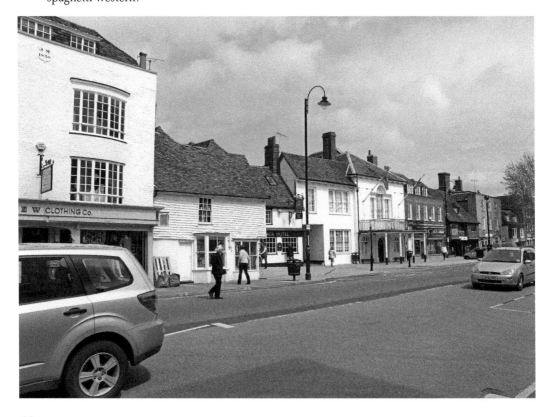

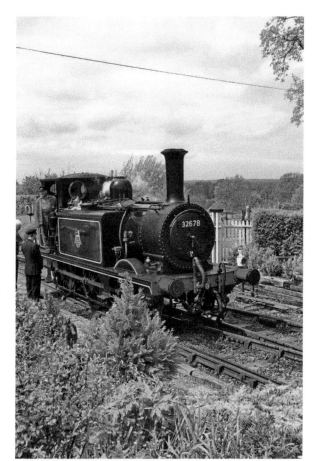

Steam Railways

Kent has many steam railways that are run by enthusiasts. The Tenterden to Bodium line and the Romney, Hythe & Dymchurch line are just two of these. The former runs on full scale old tracks abandoned at the time of Beeching's cuts. The smaller scale service along the Romney Marsh was designed to run on 15-inch-gauge tracks.

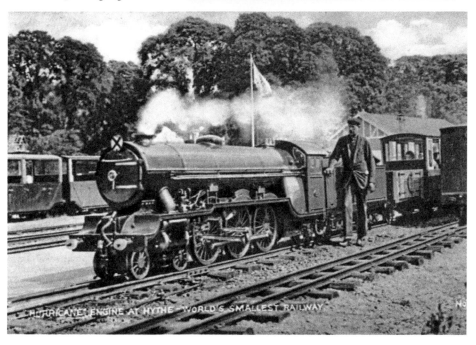

HURRICANE ENGINE AT HYTHE - WORLD'S SMALLEST RAILWAY

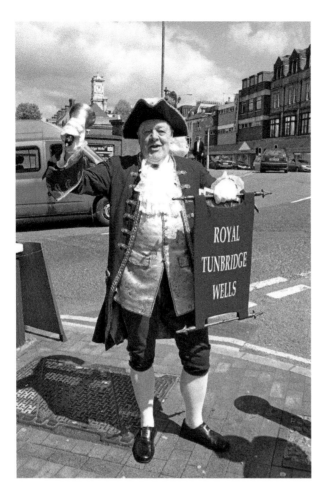

Tunbridge Wells
Tunbridge Wells retains its smart Regency atmosphere with its Town Cryer resplendent in his maroon uniform. It is an unusually attractive town due to its many open spaces where its well-known landmark, the Toad Rock, can be found.

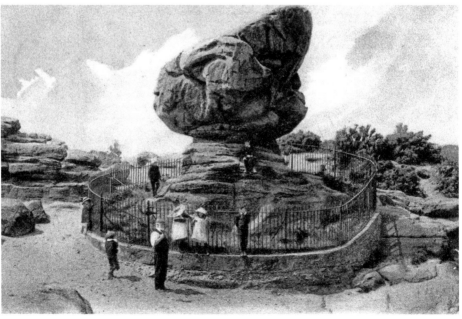

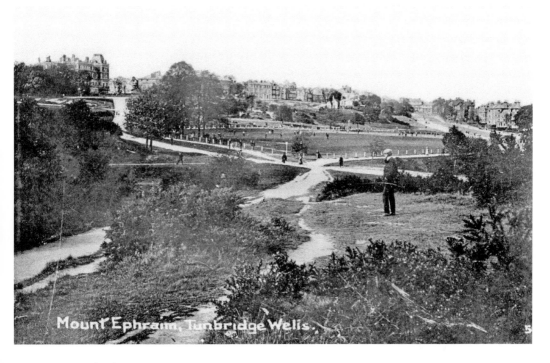

Mount Ephraim
Mount Ephraim is the largest common at Tunbridge Wells. Footpaths bisect this park dotted with outcrops of sandstone rock.

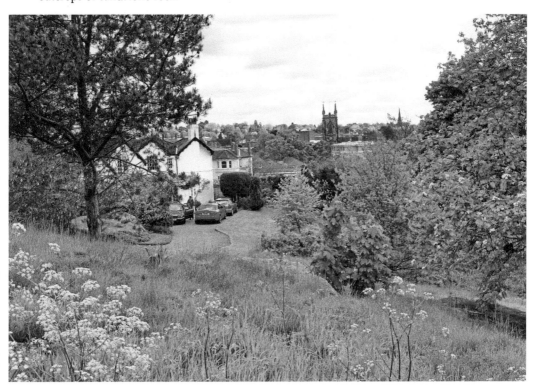

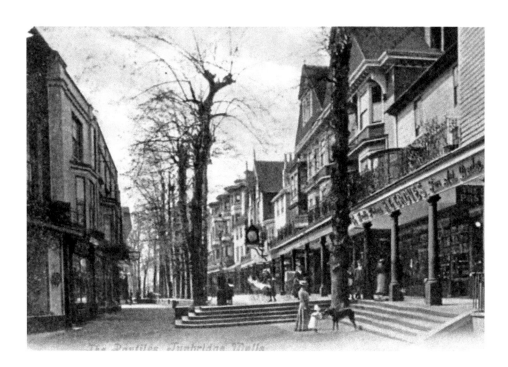

The Pantiles

The Pantiles are the most well-known view of Tunbridge Wells. They were developed near the mineral spring as a colonnaded walkway for the gentry. A strict code of practice overseen by Beau Nash meant that the lower orders of society were obliged to only use the lower walkways. Today, this area is a vibrant tourist attraction comprising cafés, unusual shops and space for open air entertainment.

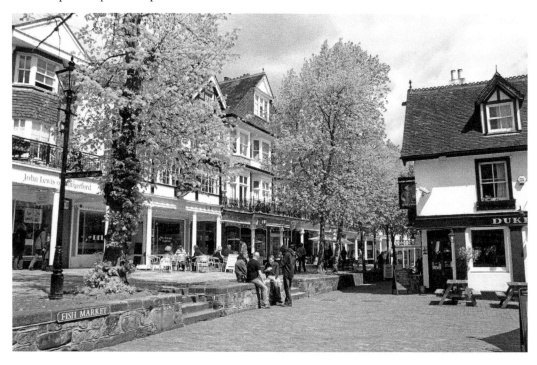

Chalybeate Spring, Tunbridge Wells

The pictures here illustrate old and new scenes at the Chalybeate Spring at the end of The Pantiles colonnade. Here eighteenth- and nineteenth-century health seekers drank the mineral waters for medicinal purposes. The fashionable set that gathered here were similar to those attending Bath as part of their social calendar.

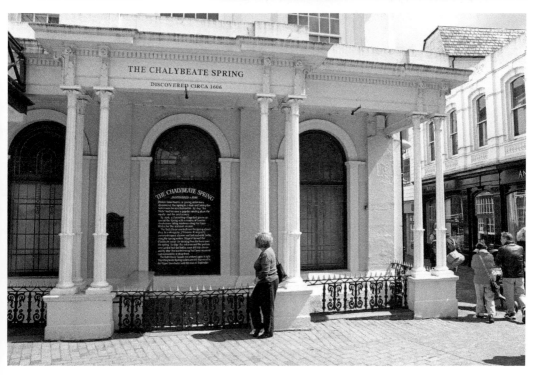

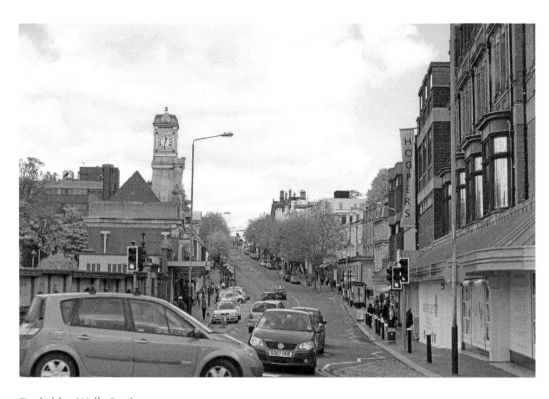

Tunbridge Wells Station
Tunbridge Wells is a major commuter town on the London to Hastings line. Its train station is by Mount Pleasant Road and was, before closure of West Tunbridge Wells station, known as Tunbridge Wells Central.

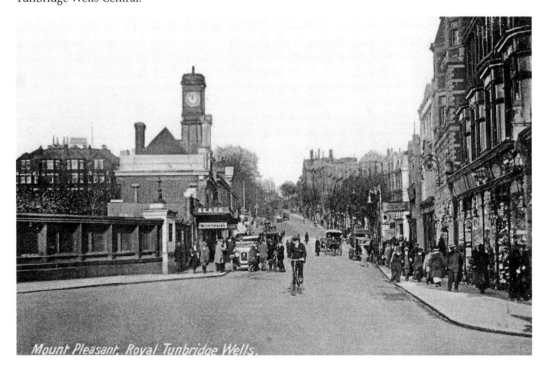

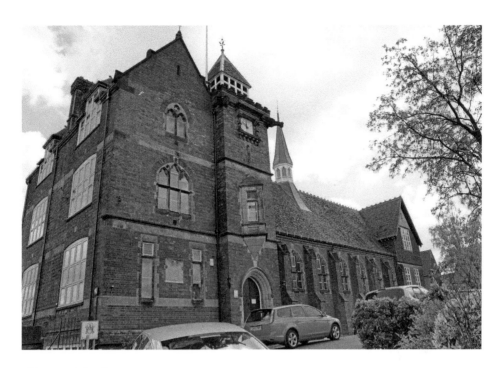

Skinners School

The Skinners School was founded in 1887 by the Worshipful Company of Skinners – one of the ancient city guilds. Their first school, now known as Tonbridge School, only accepted fee-paying pupils. The glorious school photograph below, taken around 1912, makes it easy to evoke one's imagination of this assembly rendering their school 'song of the leopards' (a reference to heraldic motifs on their coat of arms) in those halcyon golden days at the zenith of the British Empire. However, the horrors of industrial-scale slaughter was to overcome this doomed generation in Flanders fields.

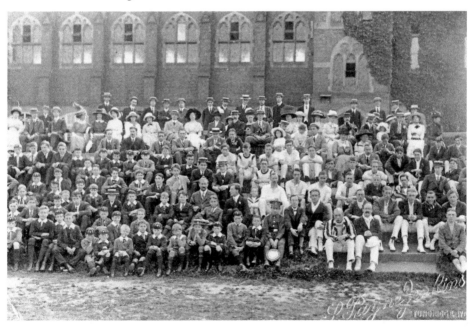

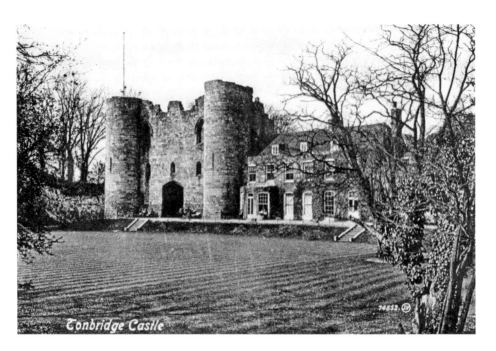

Tonbridge Castle

Following the Norman Conquest a motte-and-bailey castle was built at Tonbridge to guard the crossing of the Medway. The twin tower gate was built in the thirteenth century and is now owned by the local council.

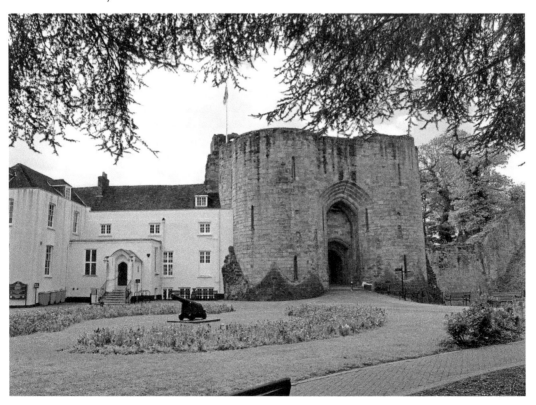

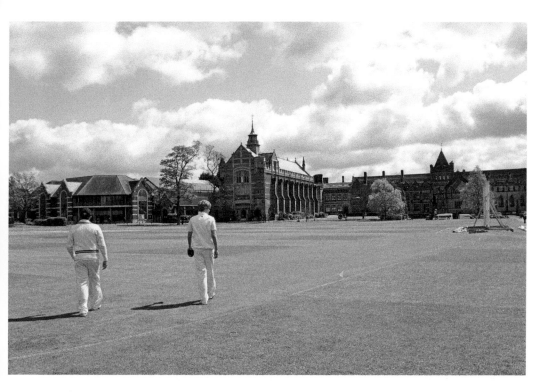

Tonbridge School

Arguably Kent's finest school, as assessed by the Wilson report on public schools and present performance, is pictured here from behind its impressive façade where a superlative cricket ground exists. It has been the nursery of many famous county and national cricketers who honed their skills here.

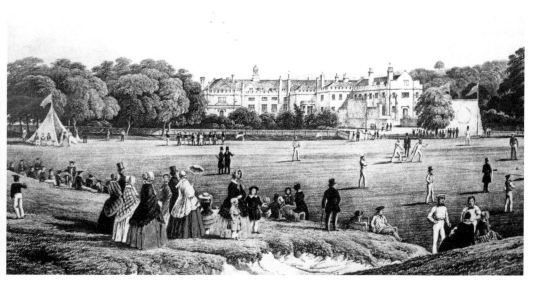

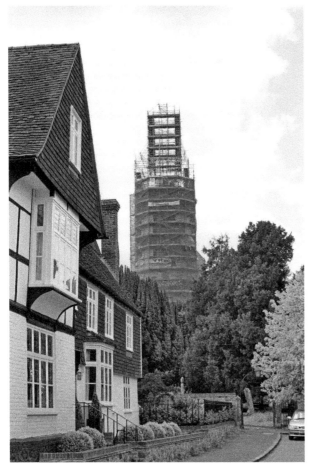

Hadlow Tower

Hadlow Castle was built on the site of an old court hall by Walter May in a then fashionable Gothic style. The tower was added in 1838 and apart from the gatehouse and stables it is all that remains after demolition in 1951. There have been many changes of ownership and major damage was done during the great storm of 1987. Eventually, Tonbridge and Malling Council sensibly purchased this unique landmark to ensure its future preservation. A specialist trust is undertaking these renovations aided by grants of £4 million from English Heritage and the Lottery. Completion of this exciting project is expected in September 2012.

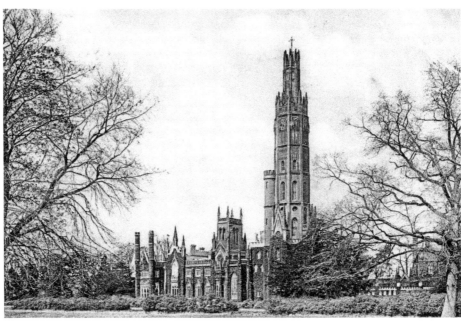

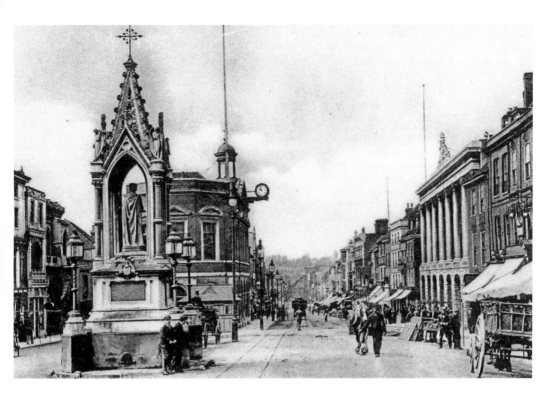

Maidstone I

Maidstone, the county town of Kent, developed from prehistoric times on the Medway River where it turns north towards the Thames Estuary. Much of the town's trade and industry depended on this waterway for its development. It was particularly well known for brewing, paper and cloth manufacture. Today, lighter industry prevails with a high density of service firms and a thriving retail sector. The main High Street pictured here has seen many minor changes over the years, but remains fundamentally intact.

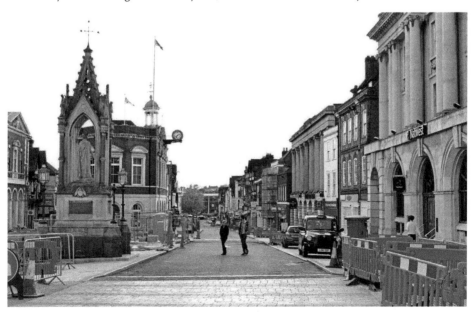

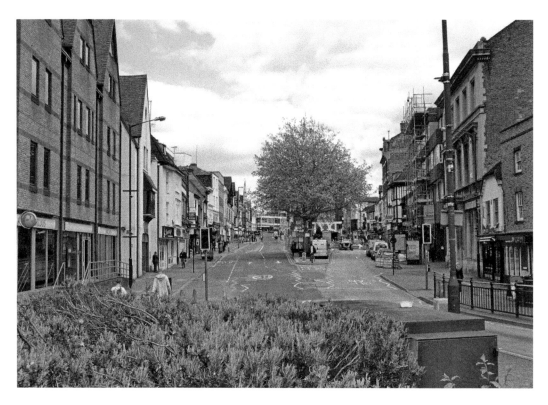

Maidstone II

Viewed from the river end of the High Street, more comparative alterations have taken place to Maidstone's central thoroughfare. Gone are the 1920s clatter of horse-drawn vehicles and vintage cars to be replaced by green urban landscape planting and traffic freer walkways.

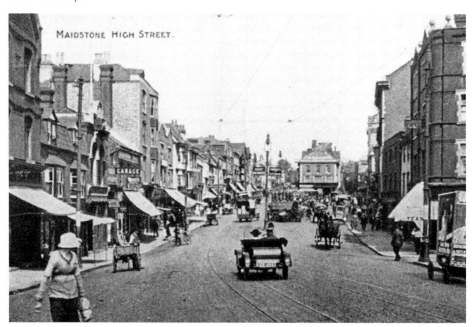

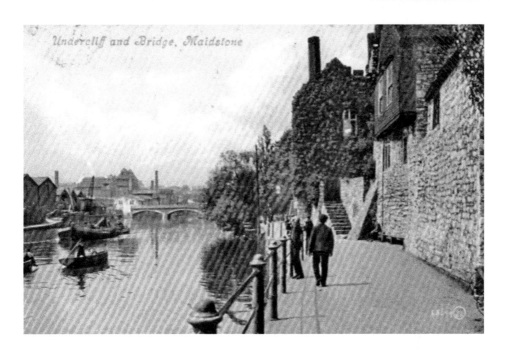

Underclyff and Bridge, Maidstone

River Medway, Maidstone

The Medway was once the main transport link to Maidstone, at the heart of Kent county. Now the river is virtually devoid of commercial vessels except those hired for pleasure. However, many leisure sailors ply their craft along its peaceful stretches together with oarsmen from the local rowing club.

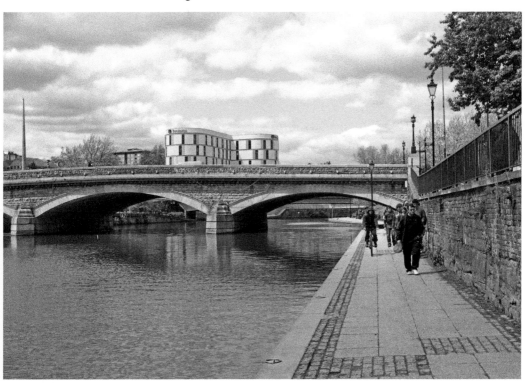

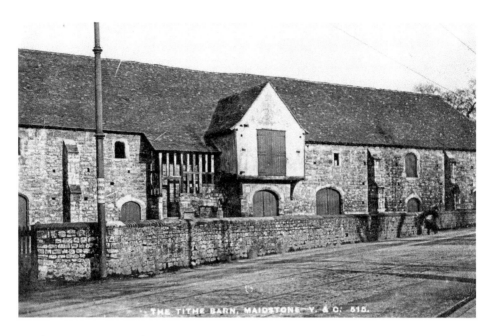

THE TITHE BARN, MAIDSTONE—Y. & C. 515.

Carriage Museum, Maidstone

The Carriage Museum at Maidstone was the inspiration of Sir Garrard Tyrwhitt-Drake who was twelve times mayor. This colourful character contributed much to his local community and is especially well remembered for owning the private zoo at his home Cobtree Manor. Dying childless this eccentric gentleman left his estate to the people of Maidstone. His home and real estate at Sandling have been transformed into a country park (containing over 600 species of trees and plants from Hillier's of Winchester) and a golf course. The old stables which were part of the Archbishop of Canterbury's riverside palace – used on his travels – house Sir Garrard's collection of carriages. He assembled them after he realised that motor cars were rapidly replacing them.

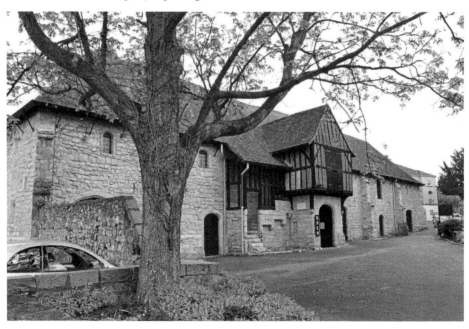

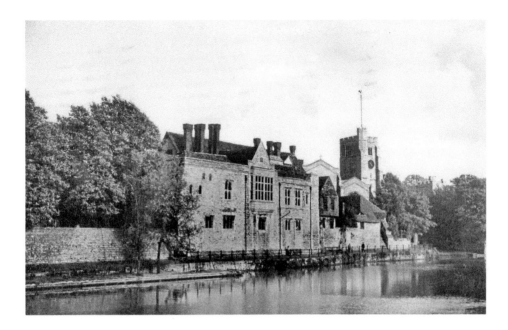

Archbishop's Palace

The Archbishop's Palace is one of a string of such magnificent buildings which ran from London to Canterbury and included those also at Otford and Charing. Others too are known to have existed at Teynham and Wrotham. The splendid stone walls of this historic structure now form part of the setting for marriage ceremonies and receptions alongside a large parish church in the same solid style.

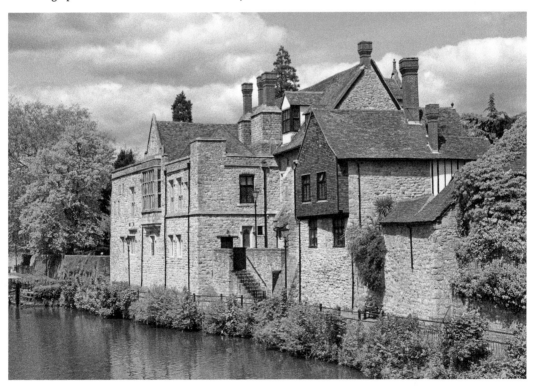

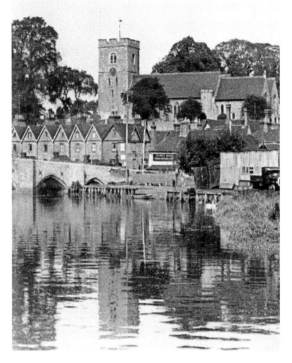

Aylesford

Aylesford is a picturesque village on the Medway near Maidstone. Its centre is of great antiquity, but it is surrounded by large housing estates and commercial buildings. The site of many ancient battles, the village is now best known for the priory comprising a religious retreat and a place of worship. It also has a British Legion village set up to provide accommodation and work for injured servicemen after the First World War.

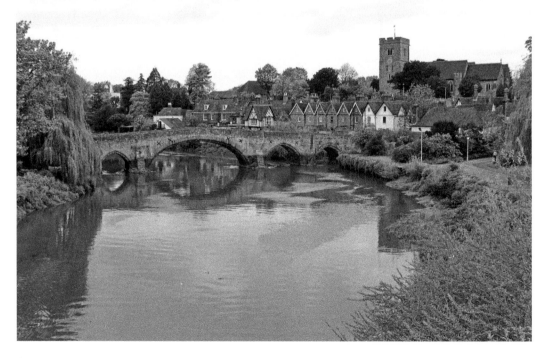

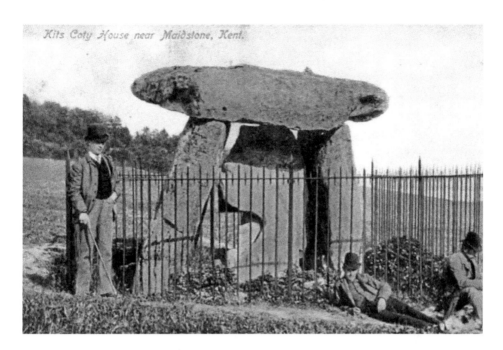

Kit's Coty

Kit's Coty is the Neolithic stone remains of an entrance to a 70-metre-long burial barrow. Standing in a gently sloping meadow near the scarp face of the North Downs called Bluebell Hill it is 1 mile or so north of Aylesford and was visited by the seventeenth-century diarist Pepys, who recorded his pleasure at having viewed this site.

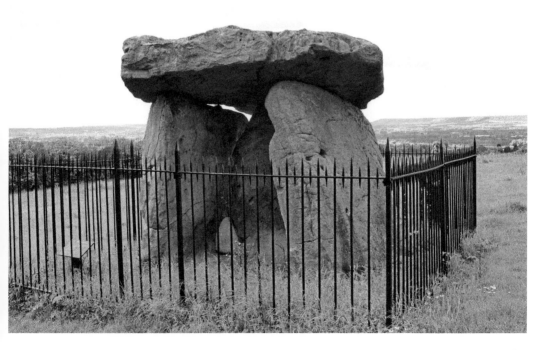

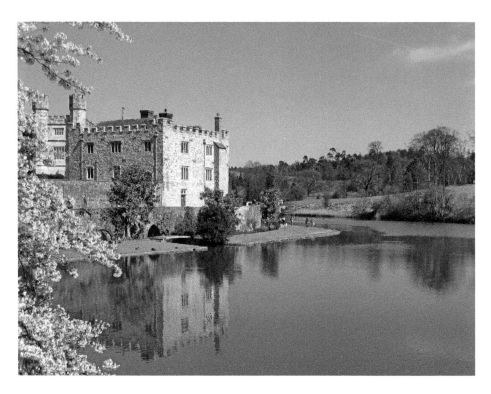

Leeds Castle I

Leeds Castle at Hollingbourne is promoted as the loveliest castle in the world. This seemingly exaggerated claim is, however, no meretricious overstatement. Surrounded by a lake, the venerable fortress and superb stately home was once frequented by Henry VIII and his second wife Anne Boleyn. The security offered by its location has more recently been used as a meeting place for international summits concerning the Middle East.

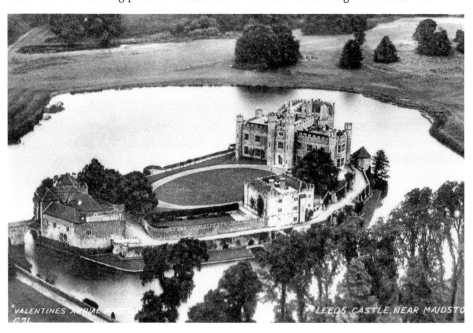

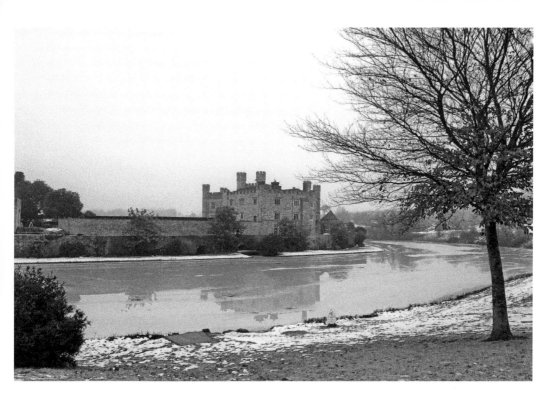

Leeds Castle II

These somewhat more austere images of Leeds Castle do nothing to detract from its truly romantic grandeur. Beautifully cared for by its last private owner, Lady Bailey, it is now managed by a charitable trust which organises many special events, concerts and other public entertainments. Sadly, the aviaries of exotic birds which housed a colourful collection of birds have recently closed and it is hoped that it will not be replaced by a 'Disneyesque' money spinner.

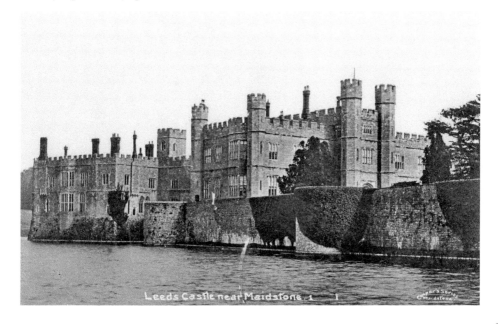

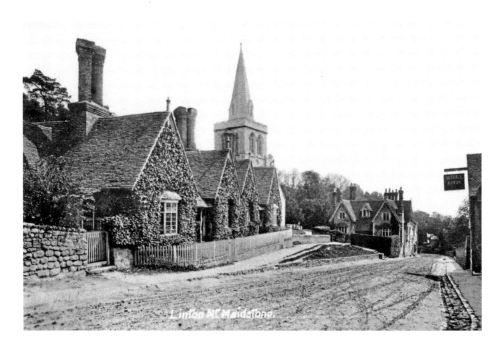

Linton

Linton is a village on the southward slope of the Greensand ridge near Maidstone. The mansion Linton Park, home of the Cornwallis family, was built here in 1730. Little has changed in this quiet community over the past century, but these pictures show changes typical of many before and after photographs spanning this period. In the old days creeper is growing more profusely over buildings and most road surfaces had yet to receive tarmacadam.

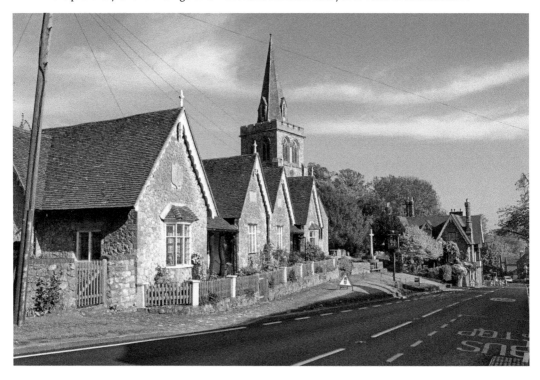

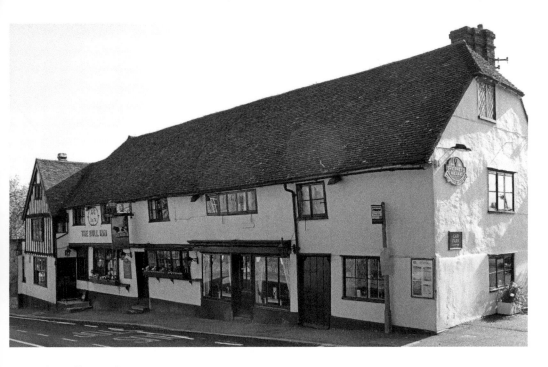

The Bull Inn, Linton

The Bull Inn, Linton nestles snugly onto the hillside affording magnificent panoramic views over the Weald of Kent below. Its patrons enjoy a good selection of meals and beer brewed in Faversham by Shepherd Neame. However, today many people arrive by car, a virtually unknown mechanical device when this atmospheric sleepy old picture was taken by a late Victorian plate glass cameraman.

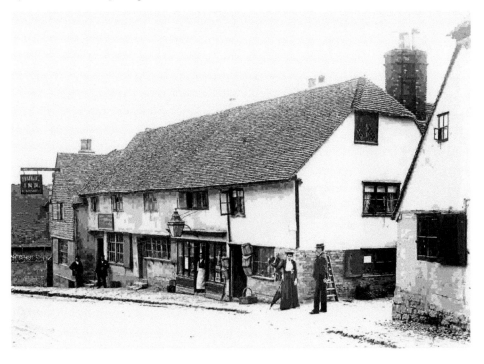

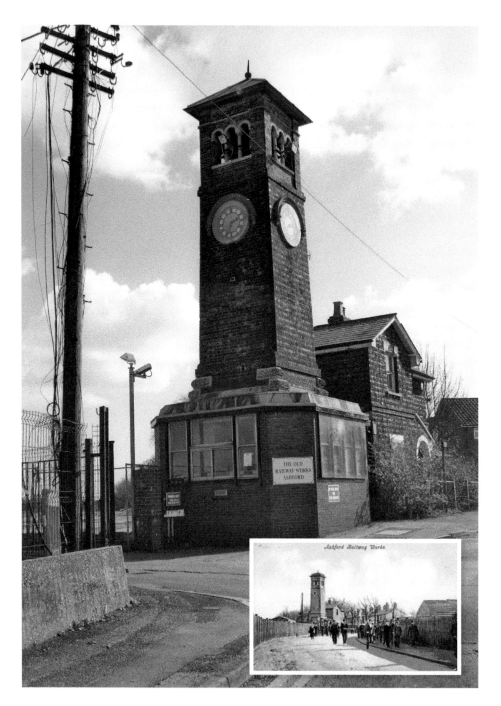

Ashford

Ashford is a rapidly growing town with vast housing estates developed to house population overspill from London. It is an important centre for marketing livestock and is best known as a communication hub for roads and especially railways. The High Speed 1 rail line has a station here on its route to the Channel Tunnel. The images on this page show the entrance to a once gigantic railway works serving South Eastern Railways which manufactured and maintained locomotives and other rolling stock.

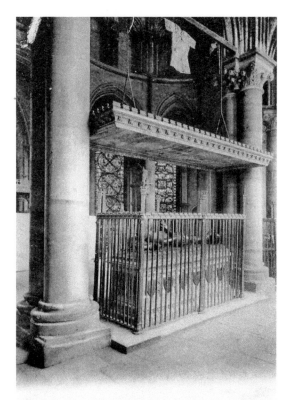

Canterbury Cathedral

Canterbury Cathedral is surely Kent's most iconic flagship building. This mother church of the Church of England was constructed during medieval times from Caen stone laboriously mined and shipped to England. Within the majesty of interior treasures is the tomb of the Black Prince, who so nobly won his spurs at the battle of Crécy.

8 CANTERBURY CATHEDRAL. — *Black Prince Tomb.* — LL.

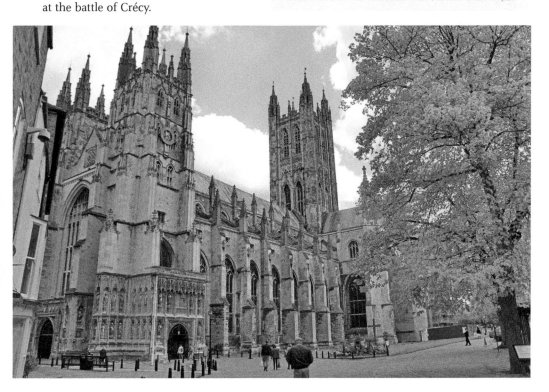

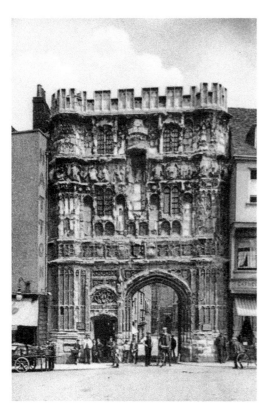

Christ Church Gateway

This main entrance to Canterbury Cathedral, which leads off from the old butter market, was built during the Tudor period. Accordingly it is adorned with this dynasty's rose emblem. The figure of a welcoming Christ (missing in the old snapshot here) is a replacement of a statue vandalised during the Civil War. Much restoration was also necessary following raids by the Luftwaffe bombers in the 1940s.

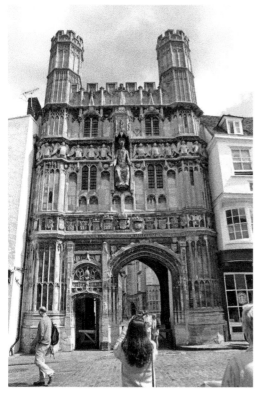

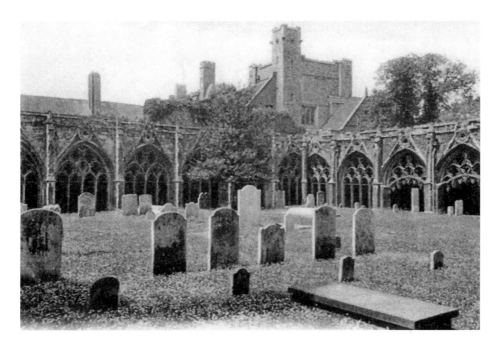

Seats of Learning

The old quadrangles of Canterbury are pictured above where centuries of monks who studied their theological texts here took their exercise. Below is a view of Kent University which was one of the new universities proposed by Harold Wilson's government of the 1960s. With strong Continental links this university excels at teaching modern languages. The students and lecturers contribute greatly to the cosmopolitan cultural life of this exciting European city.

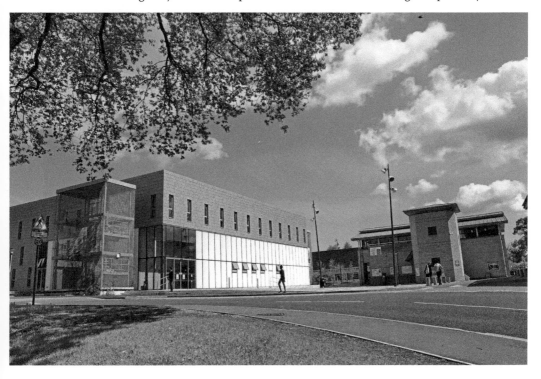

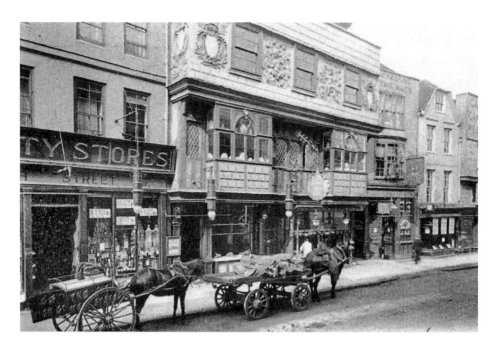

Canterbury Shops

Canterbury's retail sector is one of the largest and most diverse in Kent. Shoppers throughout the ages have been attracted to this commercially busy town since the early pilgrims travelled to the shrine of Thomas Beckett. Today, at street level, shops are constantly varying to keep pace with the vagaries of fashion. At first floor level, however, old features like this pretty pargetting are painstakingly preserved. Foreign languages are frequently overheard along the crowded walkways with crowds of schoolchildren on sightseeing tours accompanied by their parents and teachers.

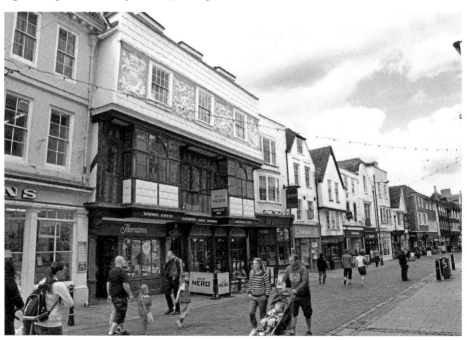

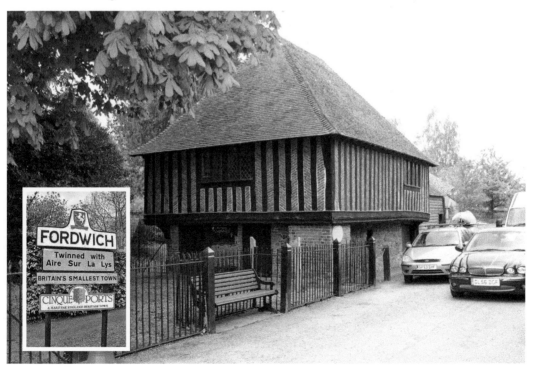

Fordwich

Fordwich is England's smallest town with a population of only around 350 souls. Its town hall pictured here was built in 1555 and houses an upstairs courtroom complete with wooden prisoners' bar and tiny jury room with a hole in its jettied floor for occupants to relieve themselves through! Parts remain of the apparatus used to duck witches alongside the jetty where imports of stone and other goods were imported before the silting up of this channel cutting off the Isle of Thanet.

FORDWICH
Twinned with
Aire Sur La Lys
BRITAIN'S SMALLEST TOWN
CINQUE PORTS
A MARITIME ENGLAND HERITAGE TOWN

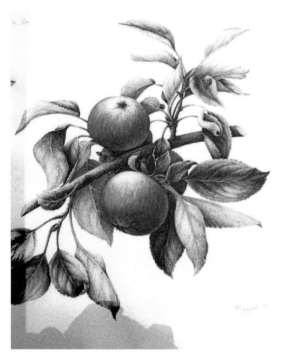

Detail from Cox's Orange Pippin at Brogdale – in the author's collection – by kind permission of artist Margaret Brooker SBA.

Oh! Men of Kent! And Kentish Men!
Right happy may you be,
Because of all broad England's Shires
The fairest falls to thee.

Last verse from *A Song of Kent* by Margaret Owen

Acknowledgements

Increasingly I am indebted to my beloved partner Jocelyn whose enthusiasm, energy and encouragement have made producing this volume such a joyous and pleasurable experience reinforcing my knowledge and affinity for my native county. Thanks also go to Trac Fordyce for the loan of pictures and computer assistance. I am also grateful for the trust of Chris Rapley who hired a group of old postcards to be scanned and Josie Wyeth is thanked for her snapshots of Leeds Castle. Should I have failed, through any error of omission or commission, to include anyone who has contributed in any way, I apologise and will naturally include their details in any subsequent reprint.